WELL HEELED

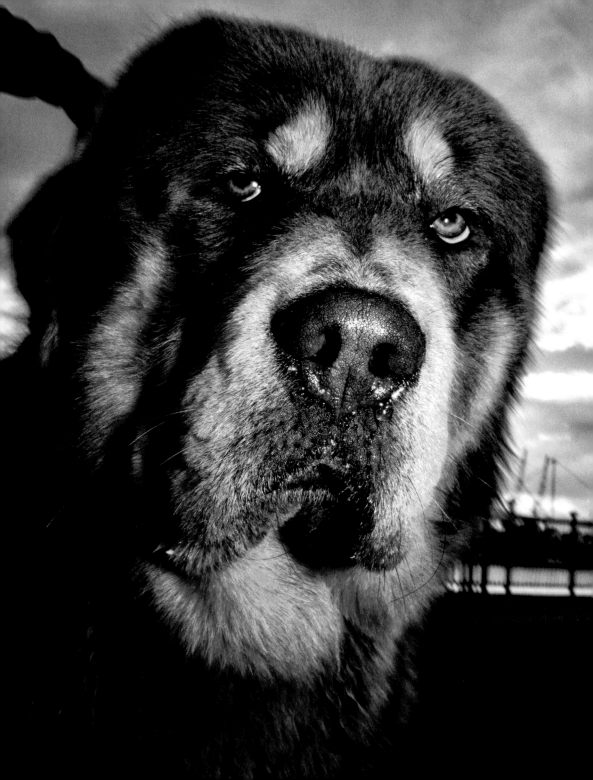

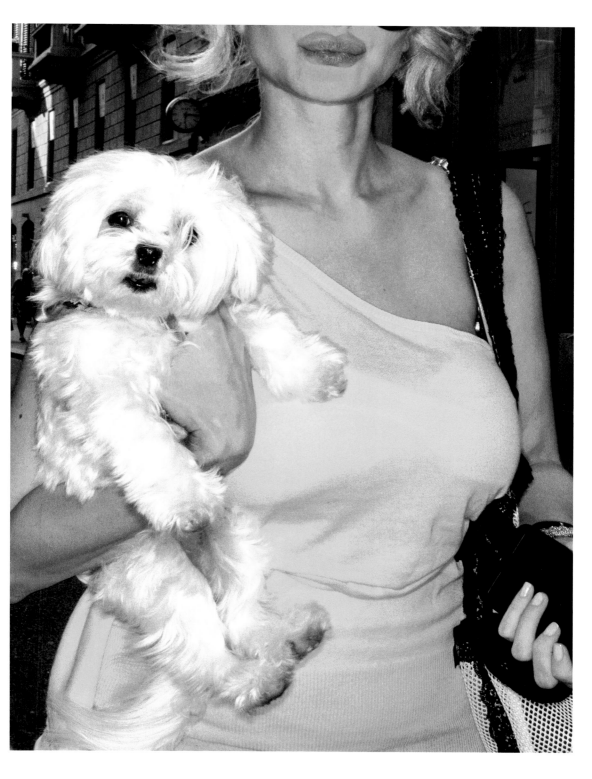

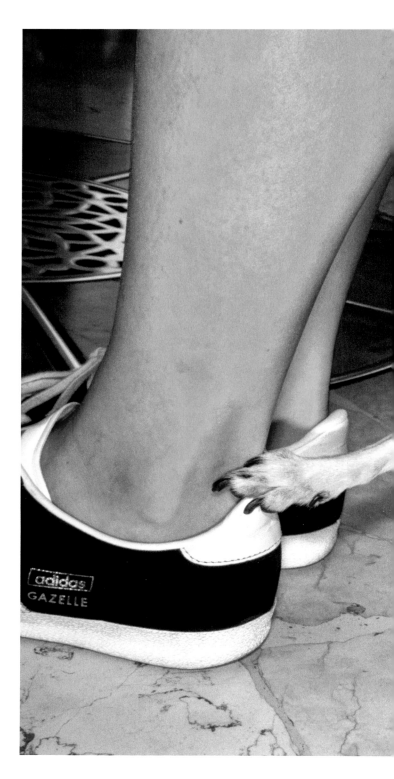

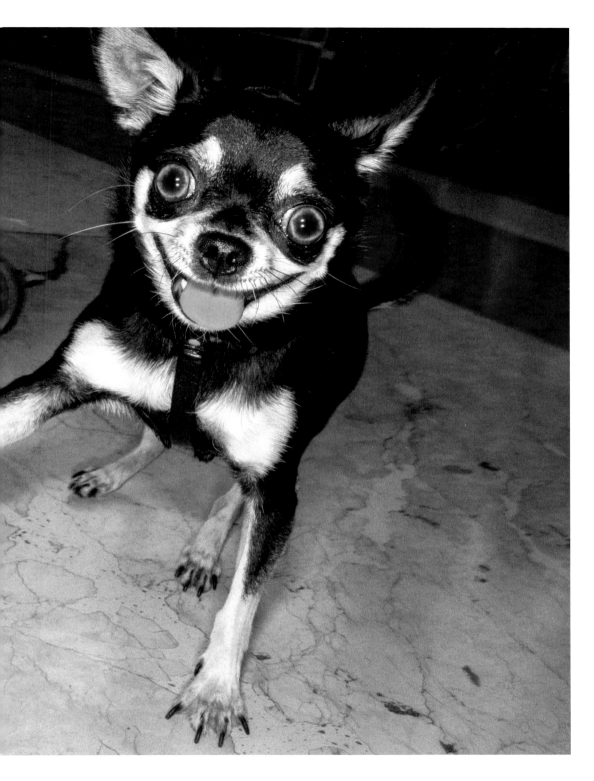

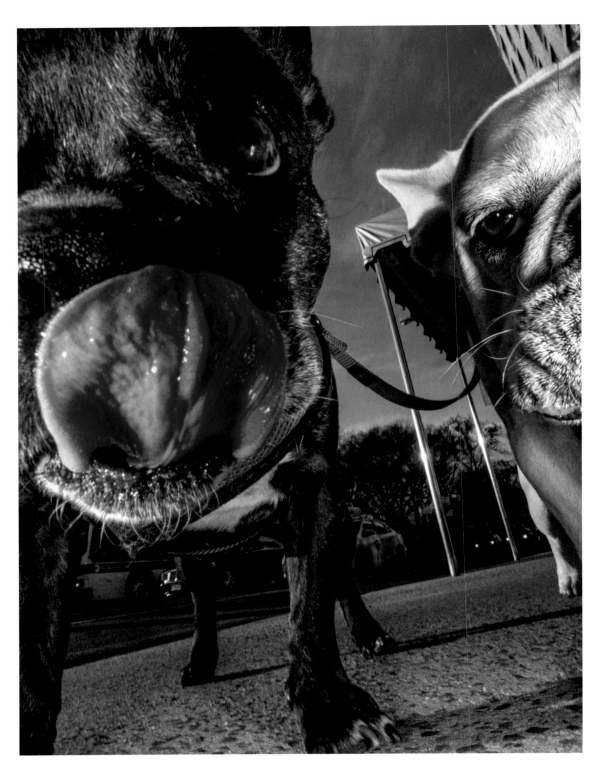

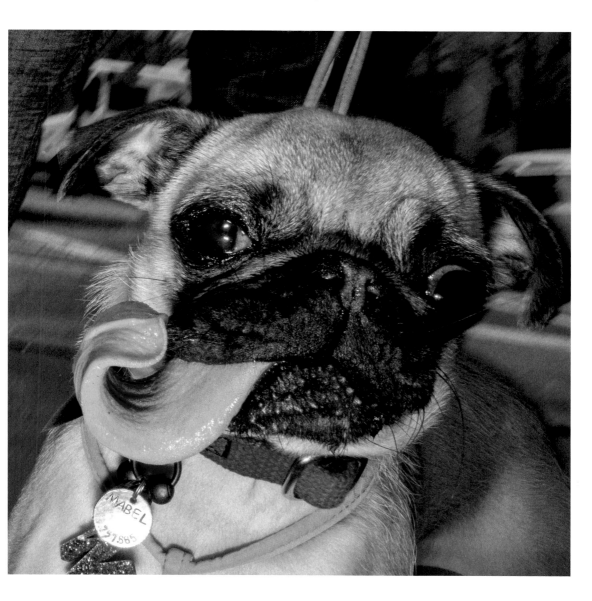

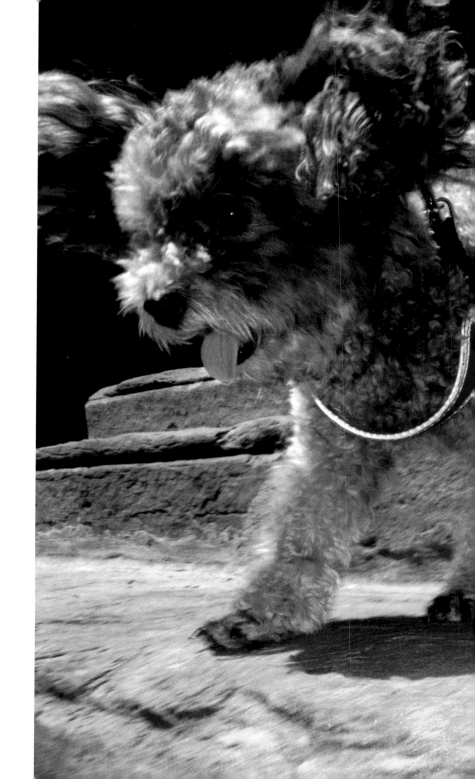

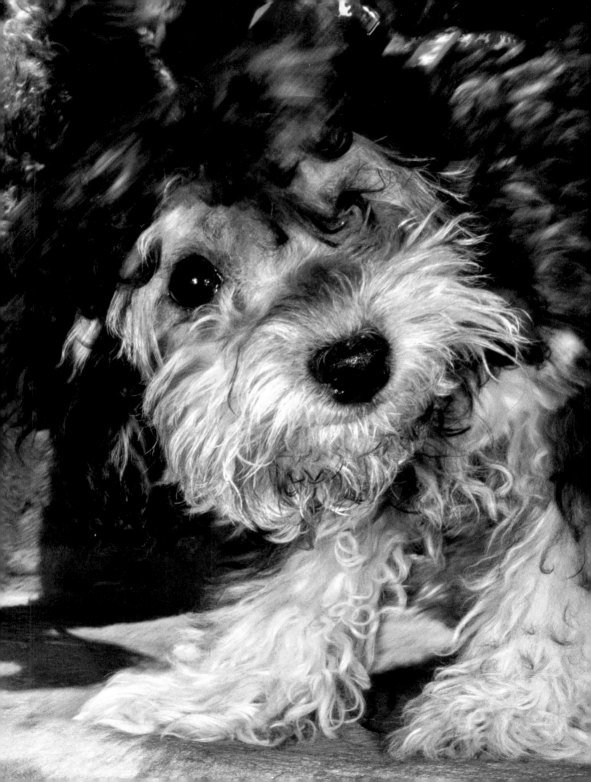

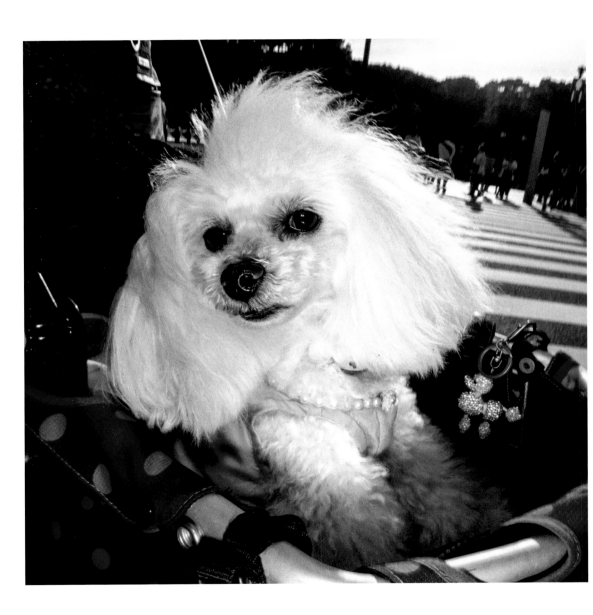

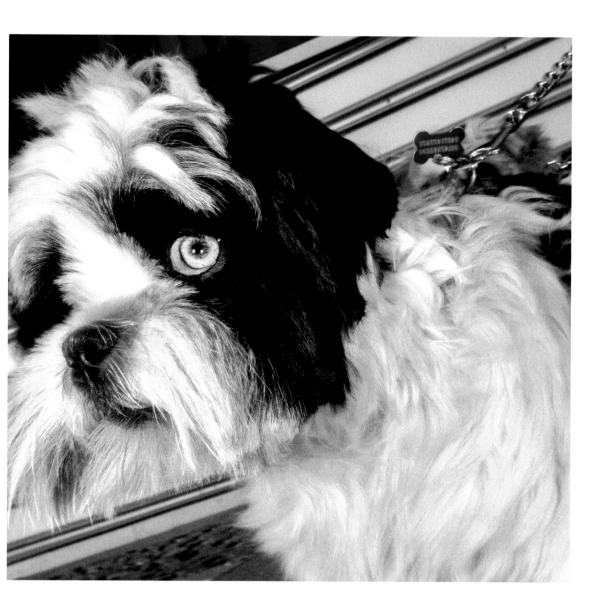

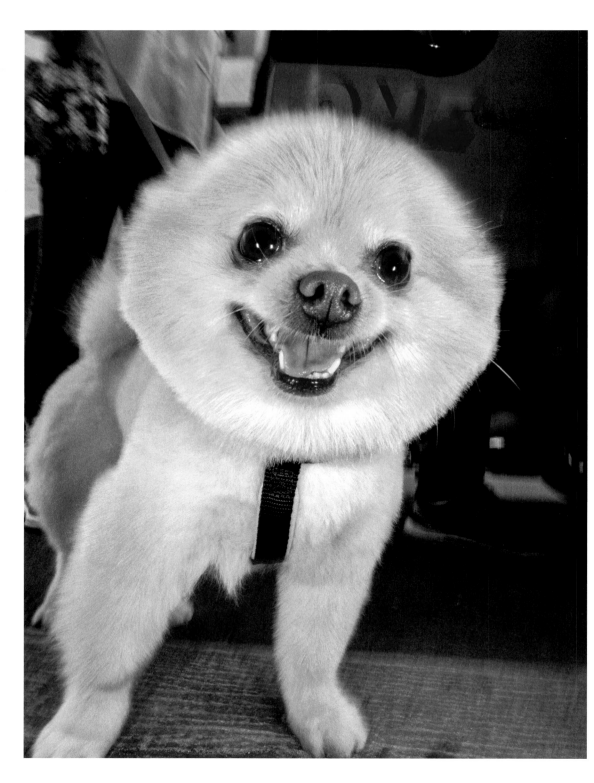

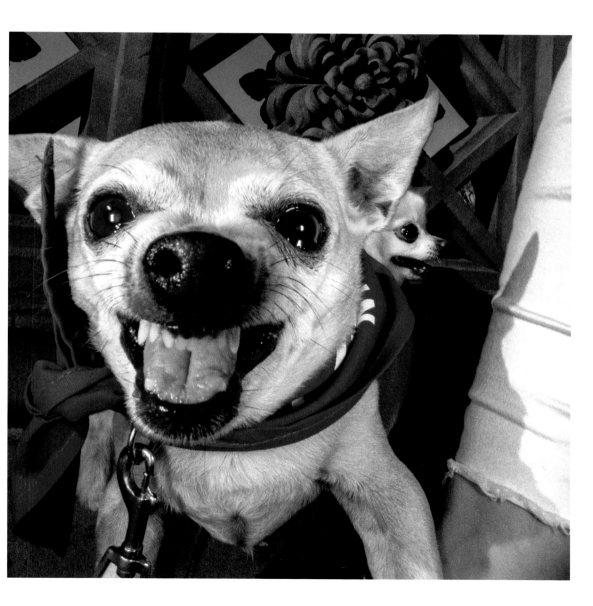

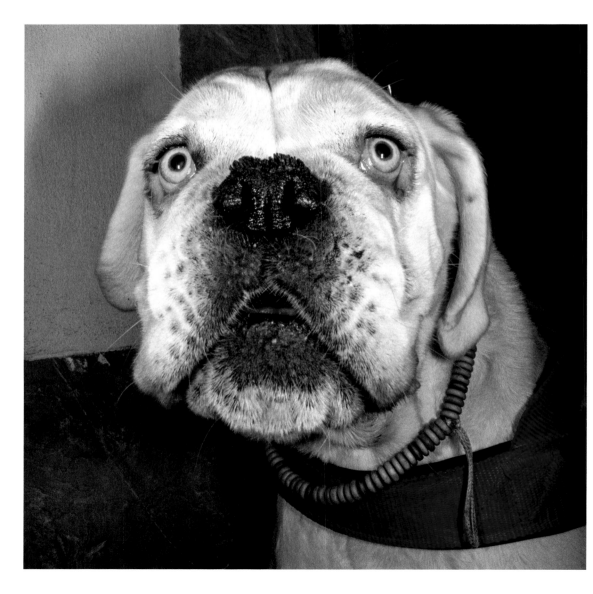

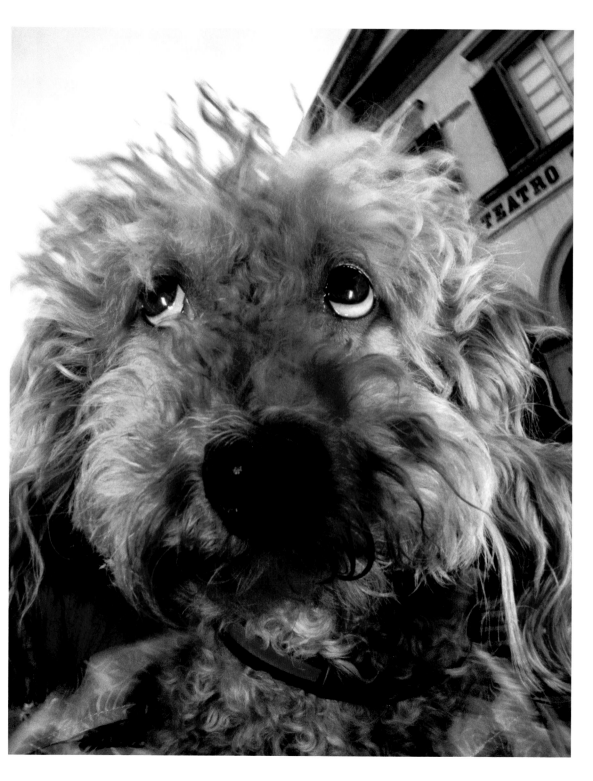

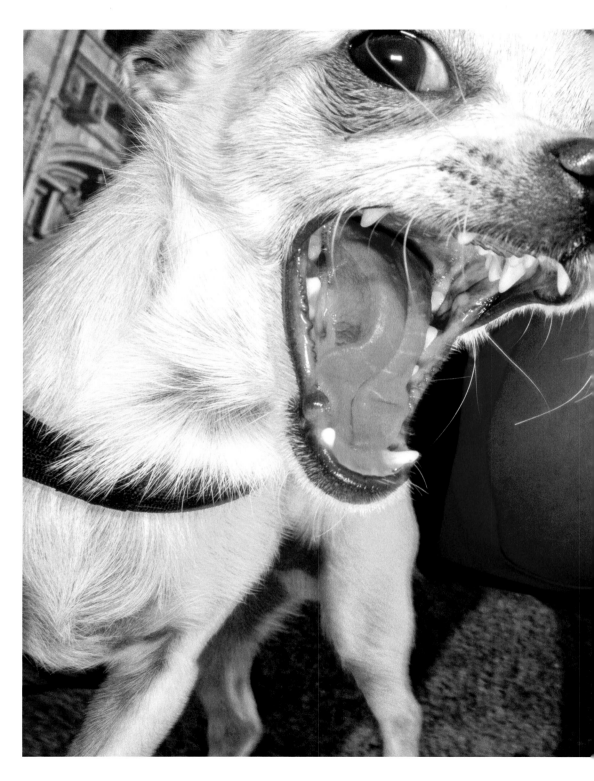

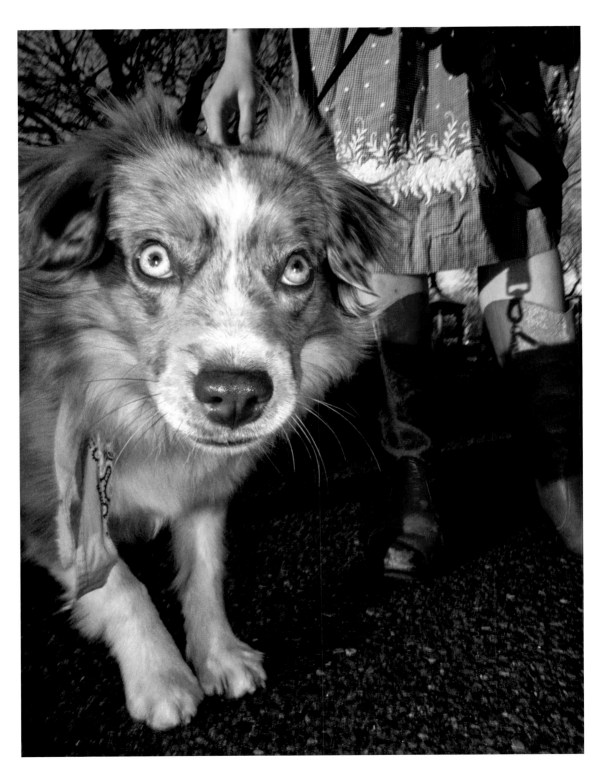

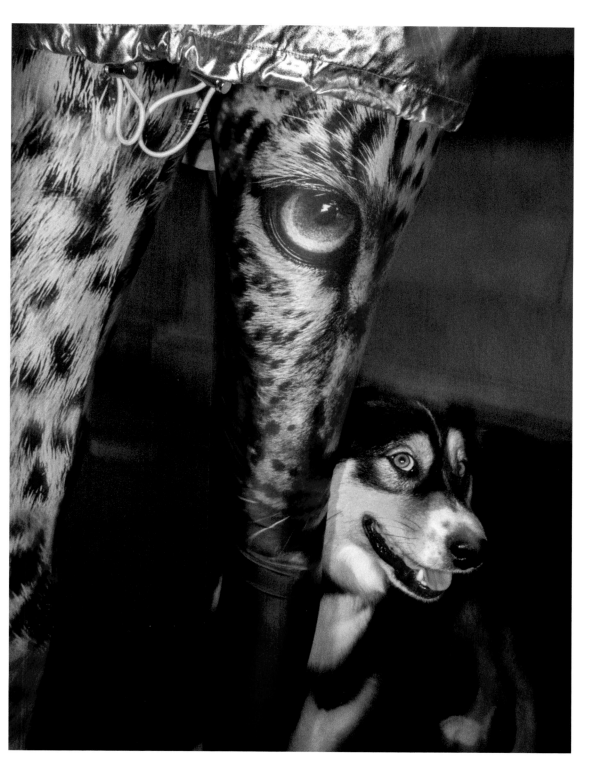

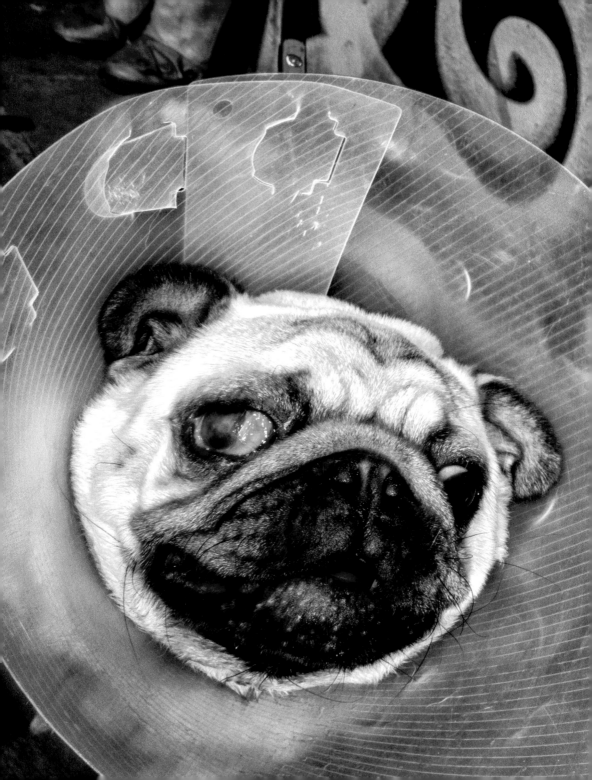

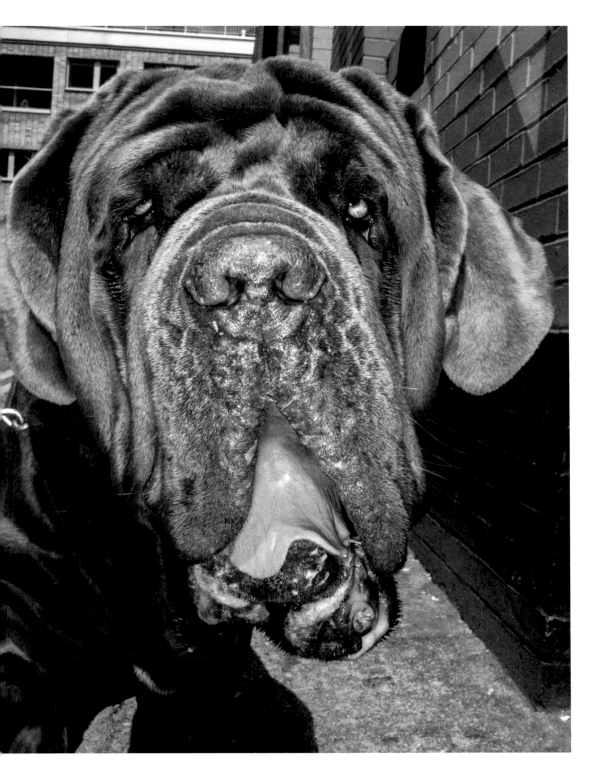

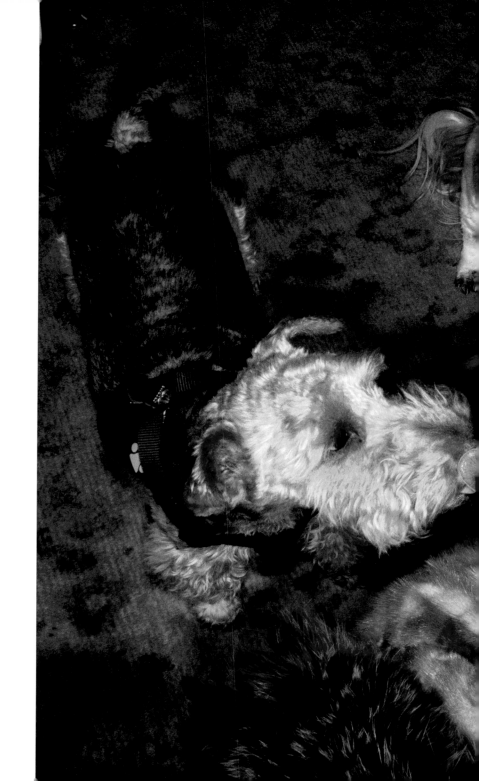

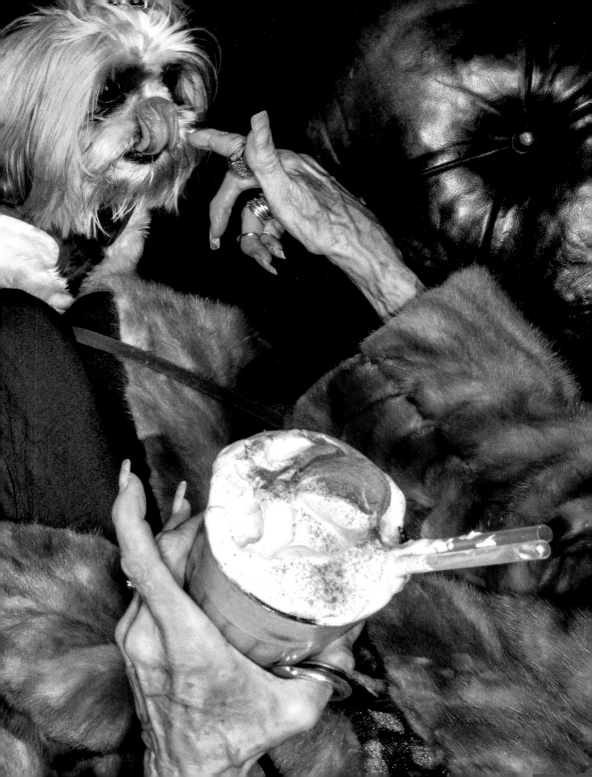

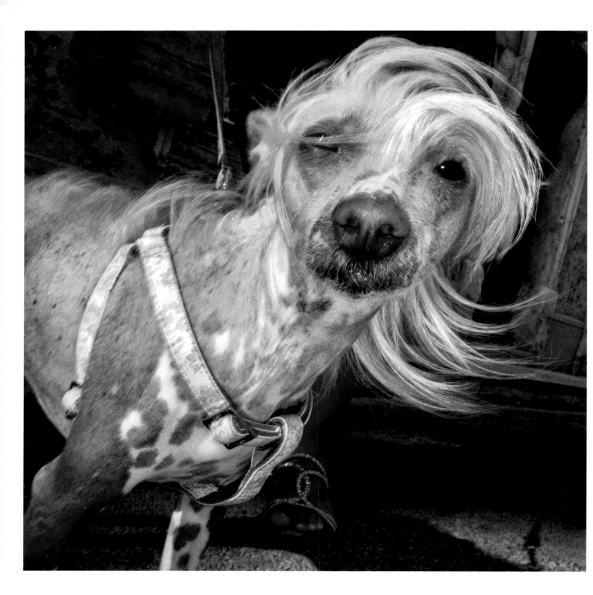

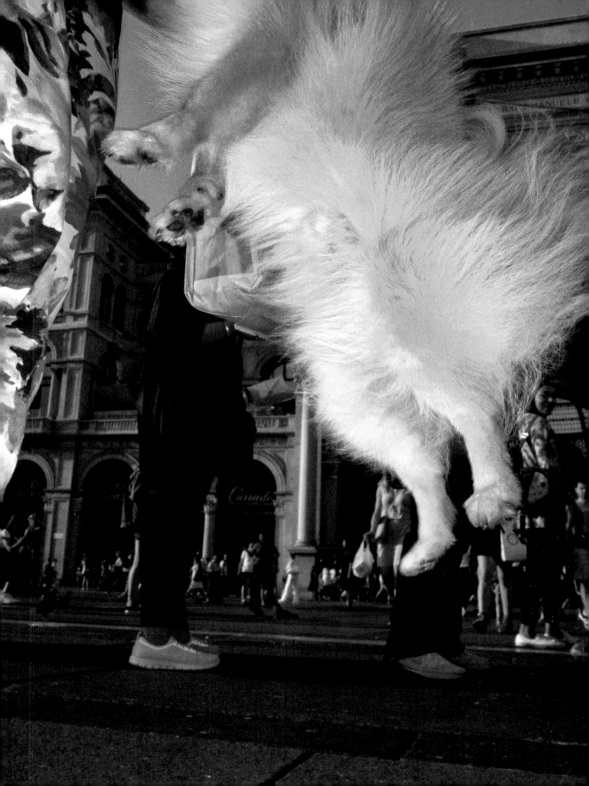

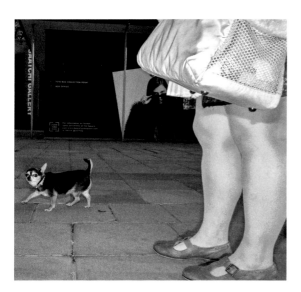
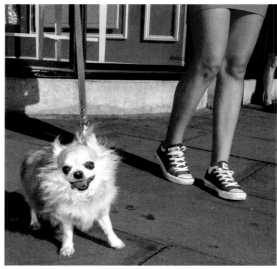
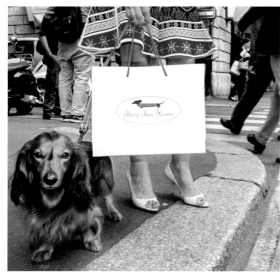
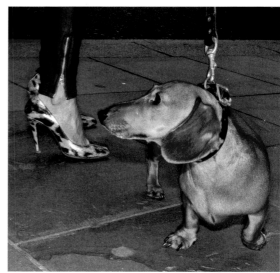

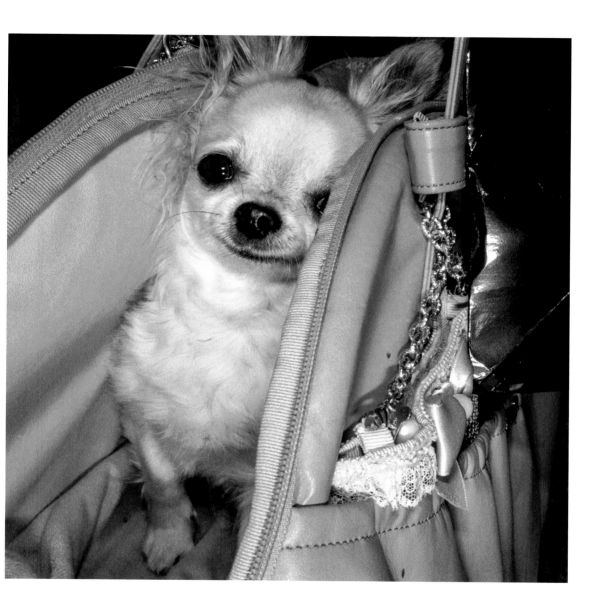

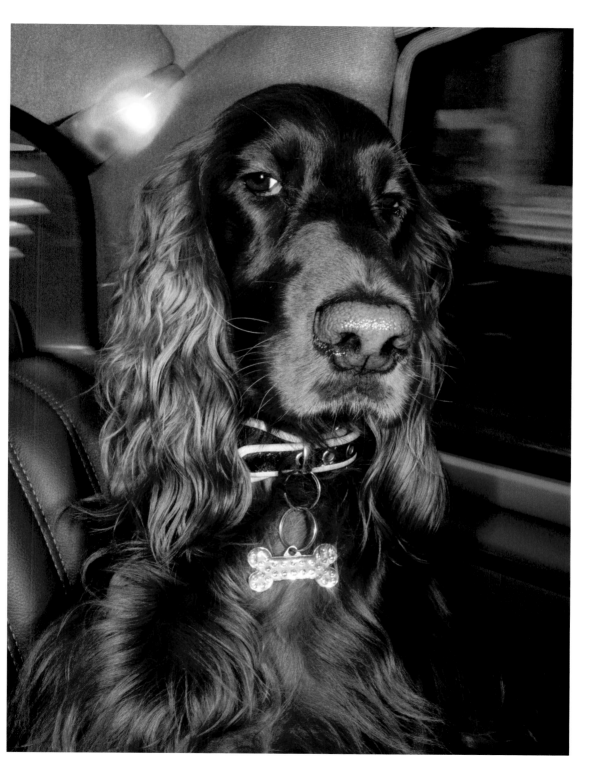

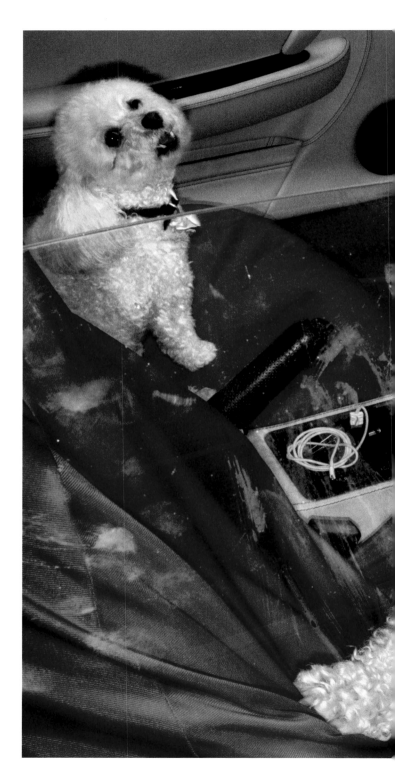

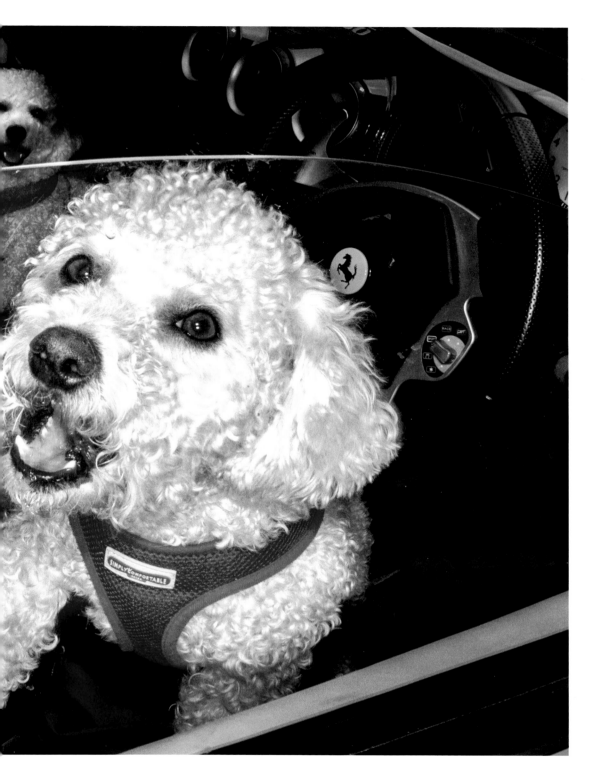

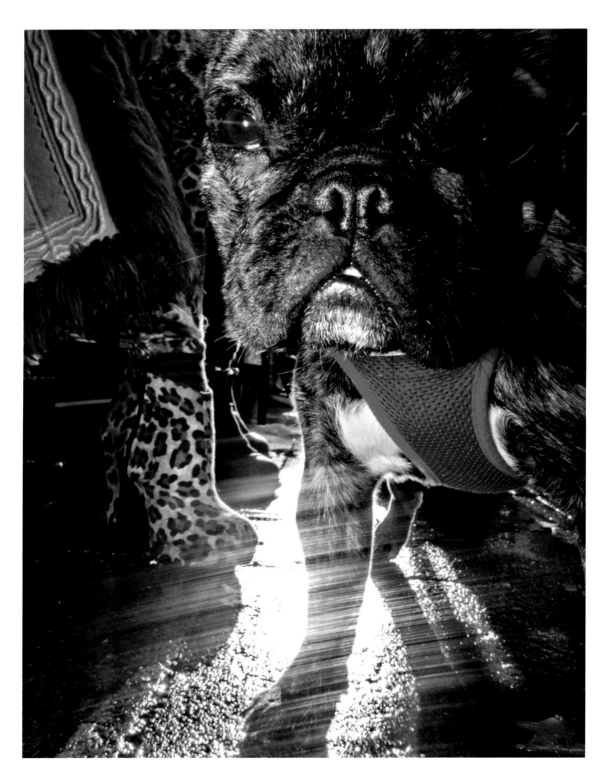

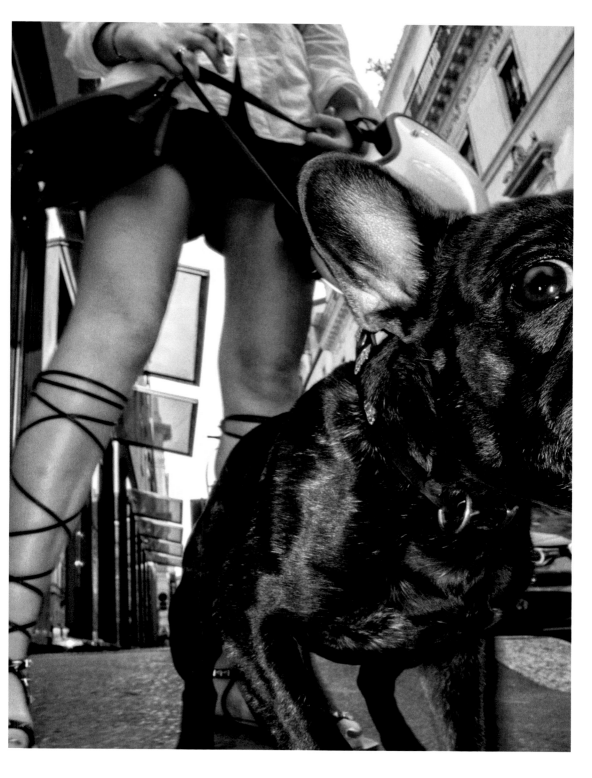

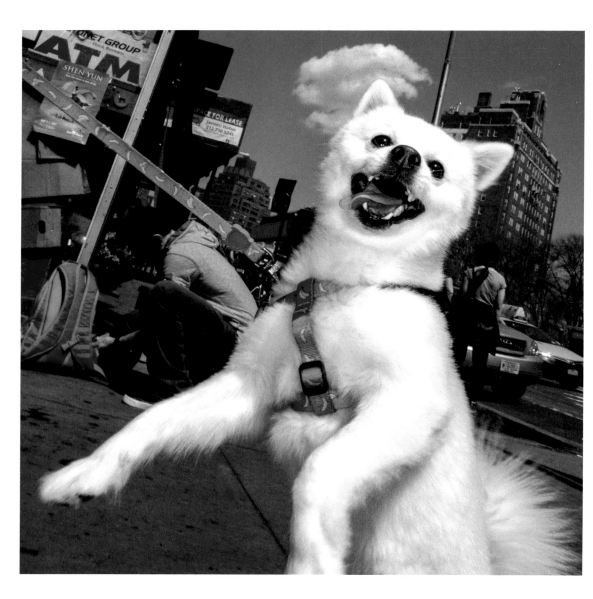

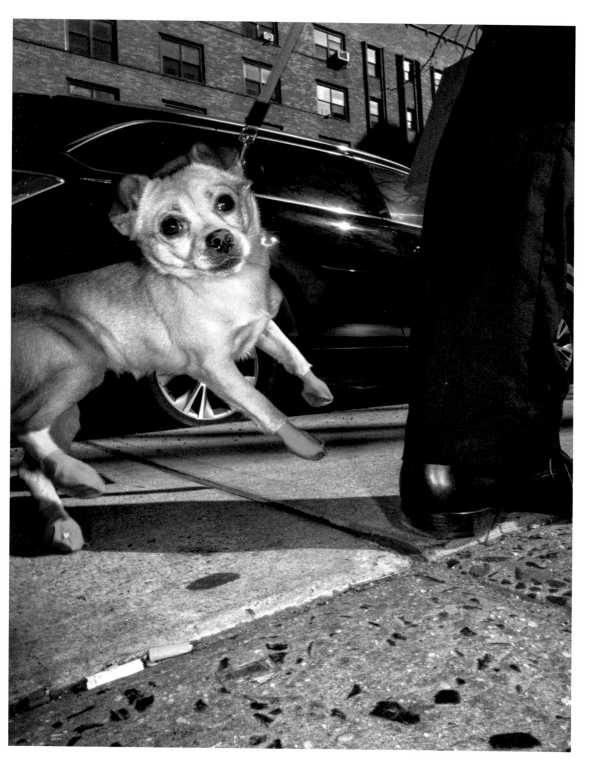

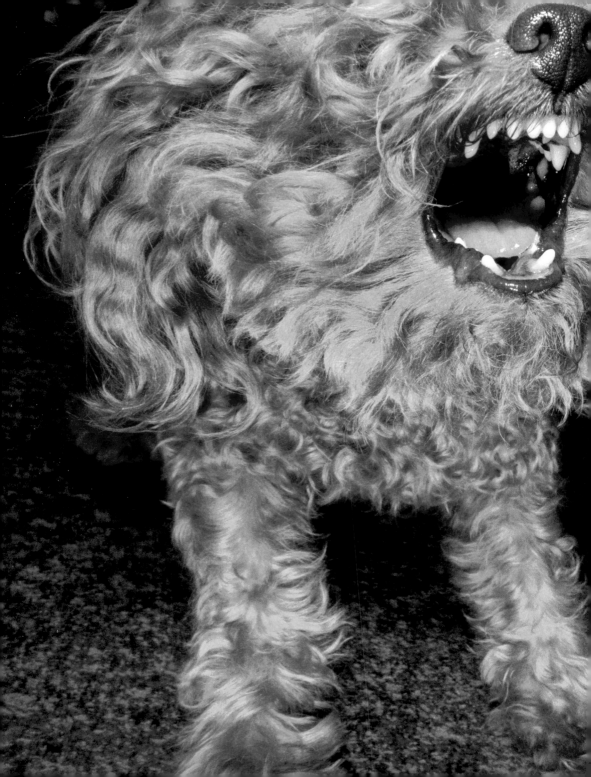

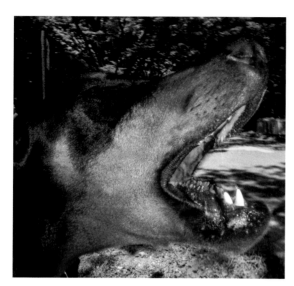
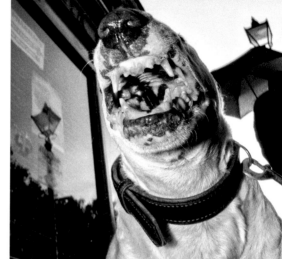
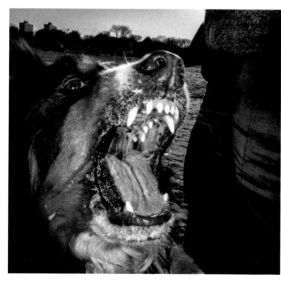
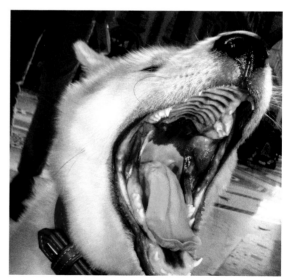

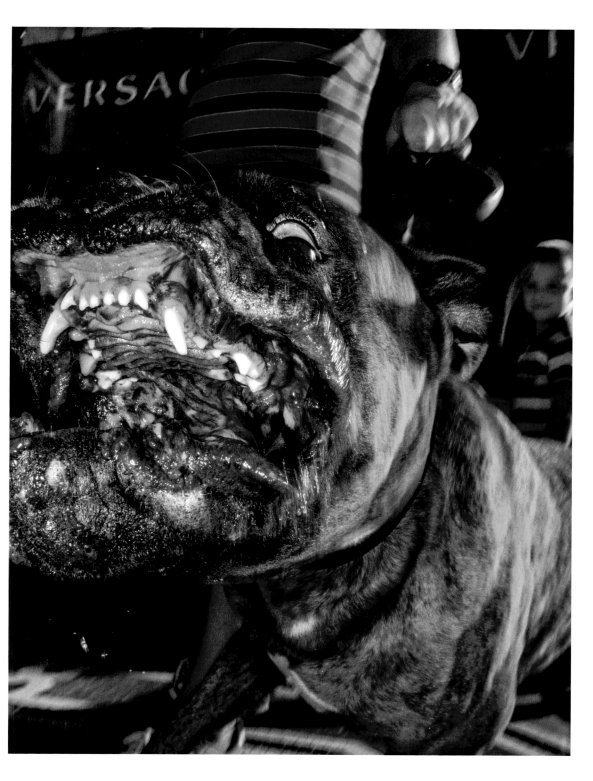

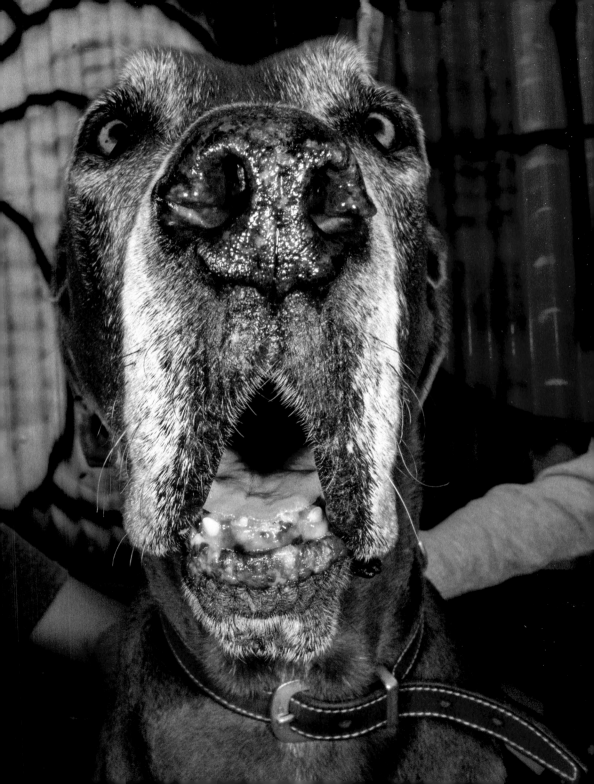

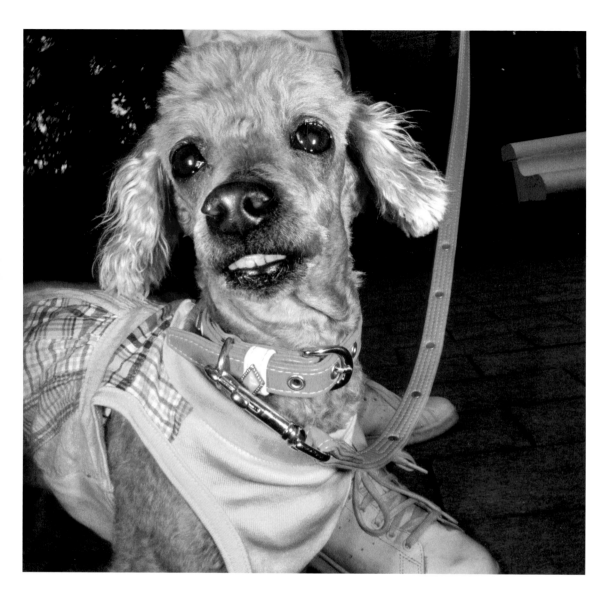

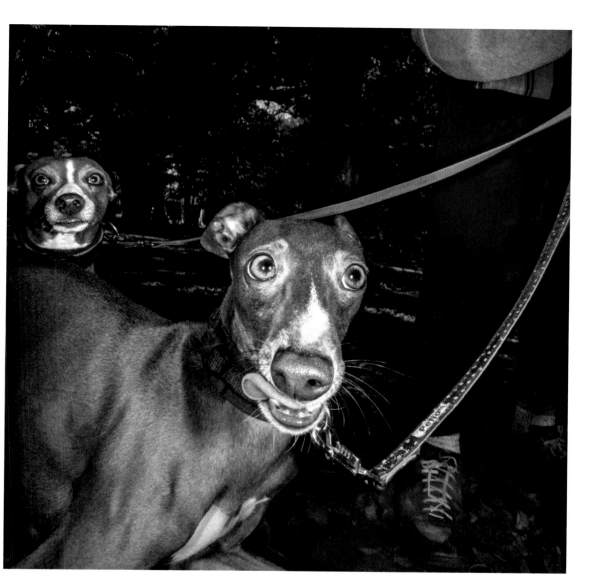

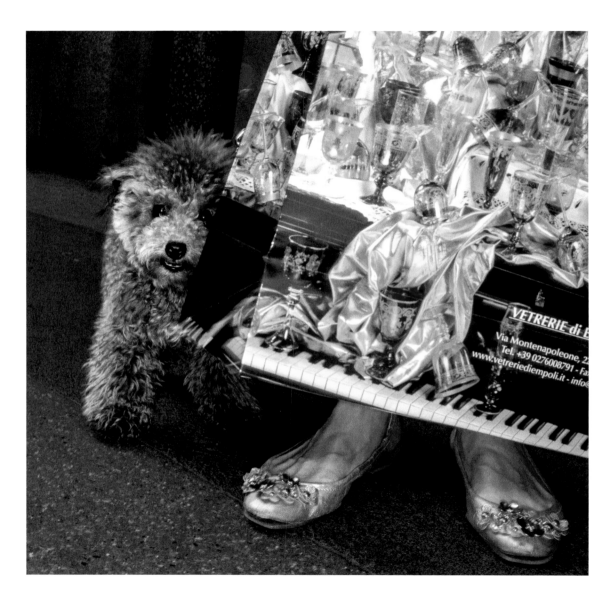

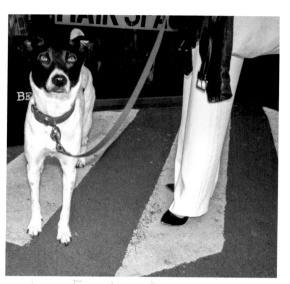
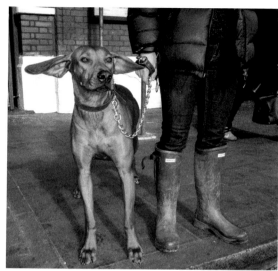
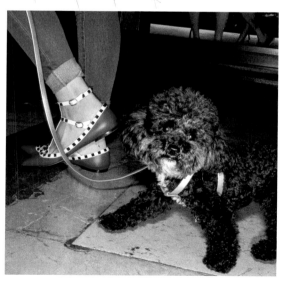
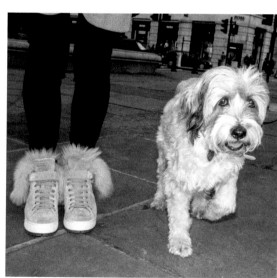

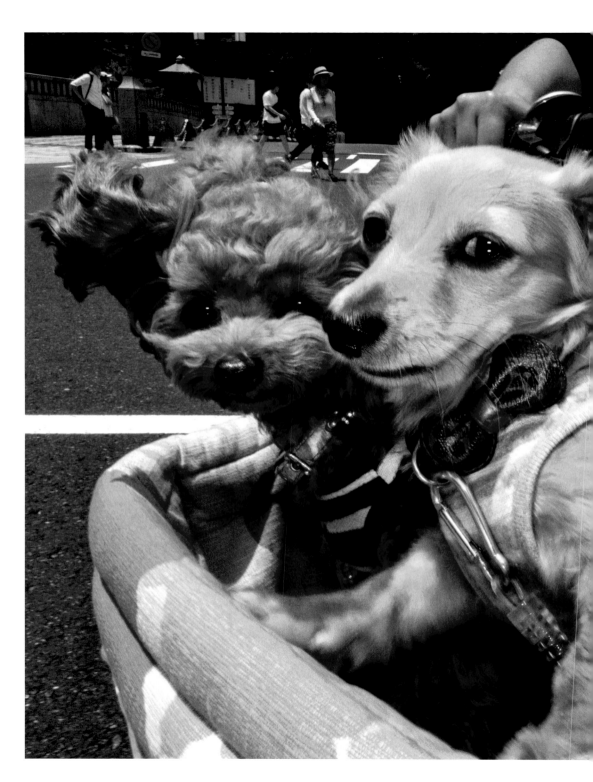

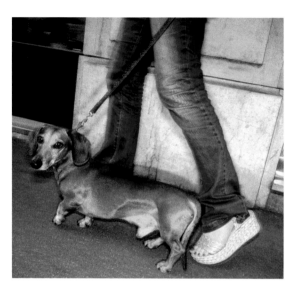
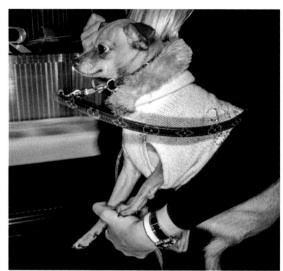
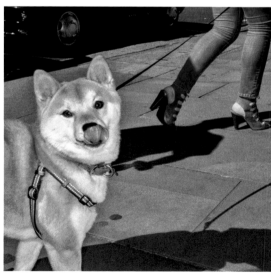
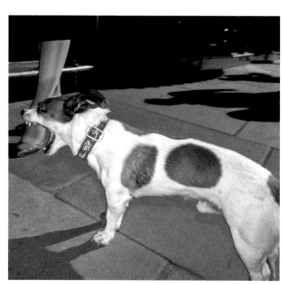

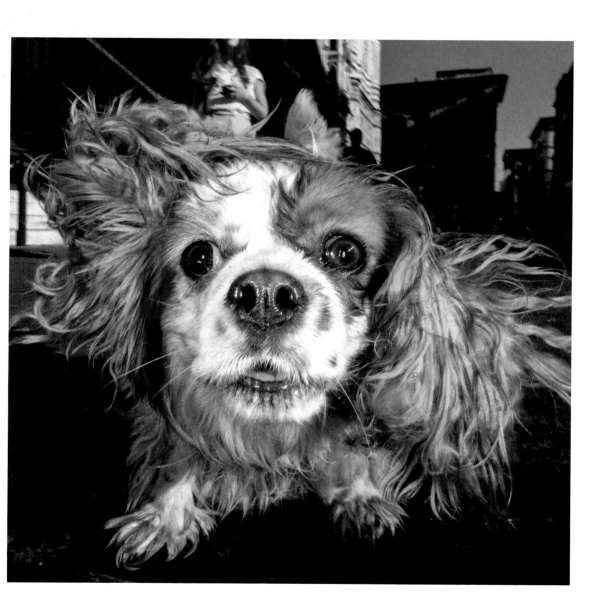

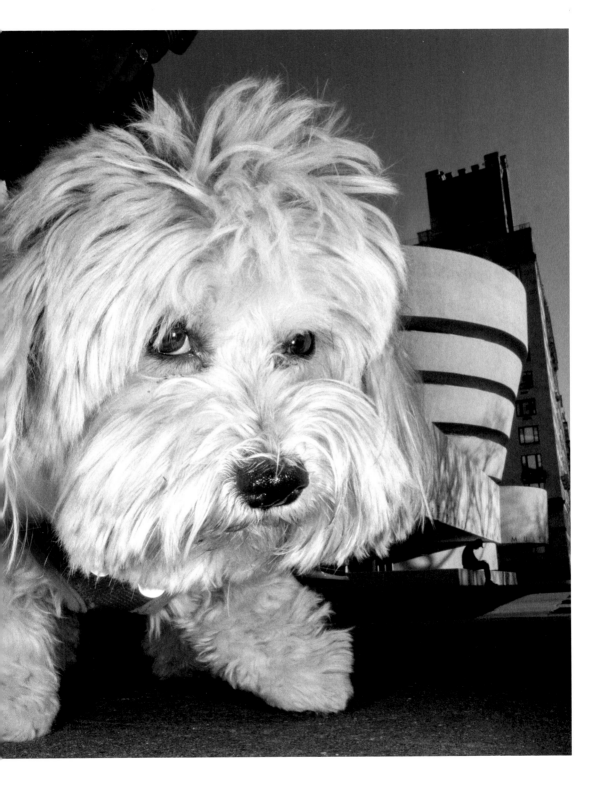

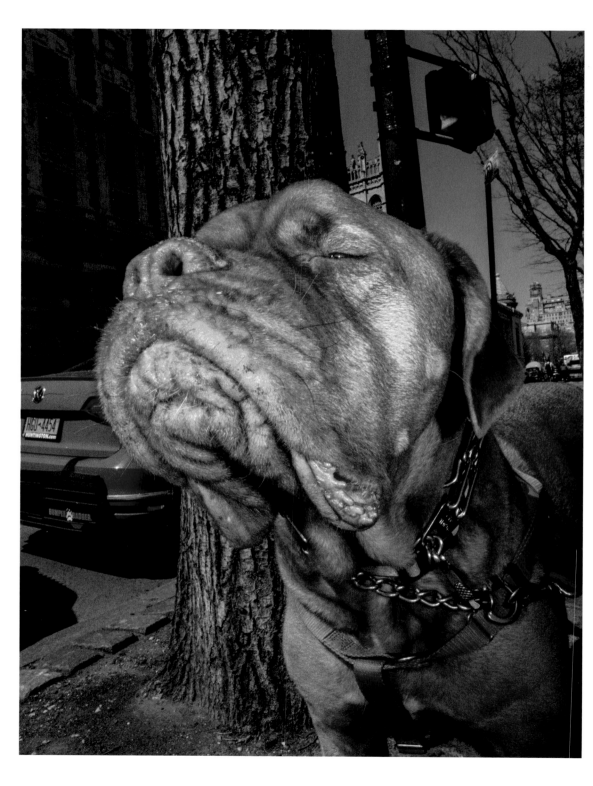

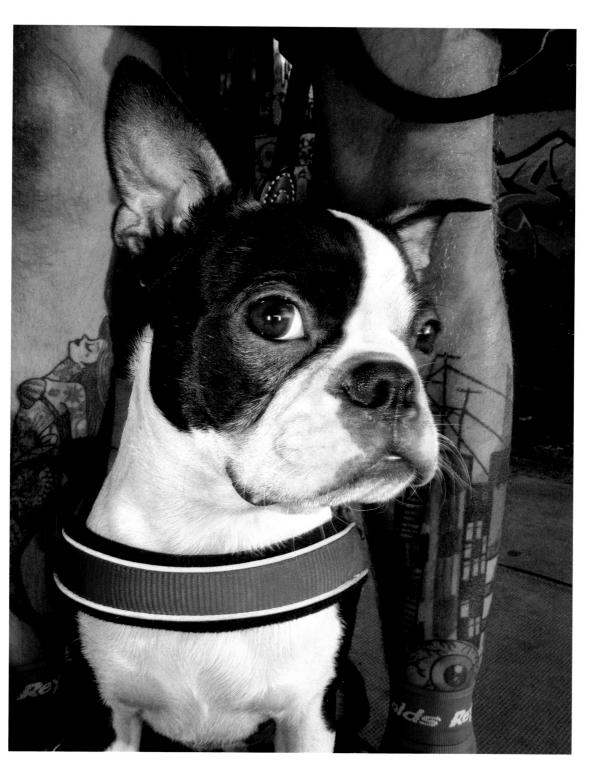

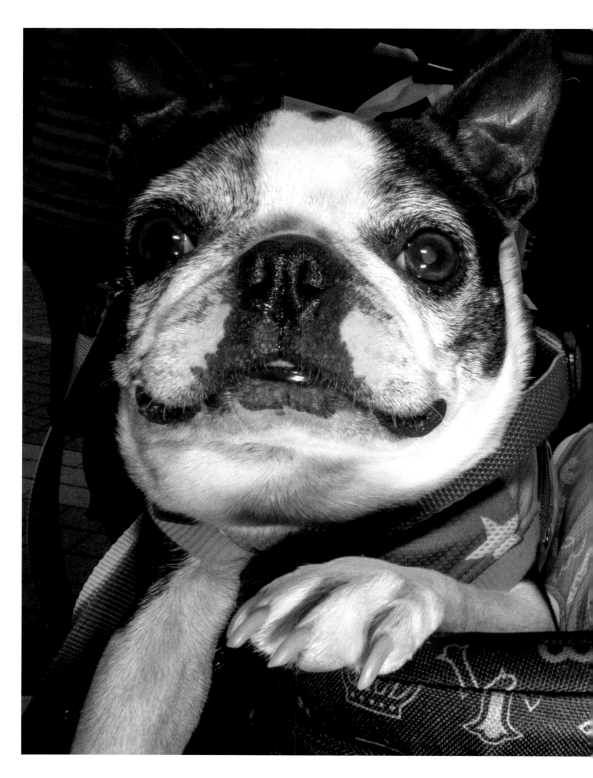

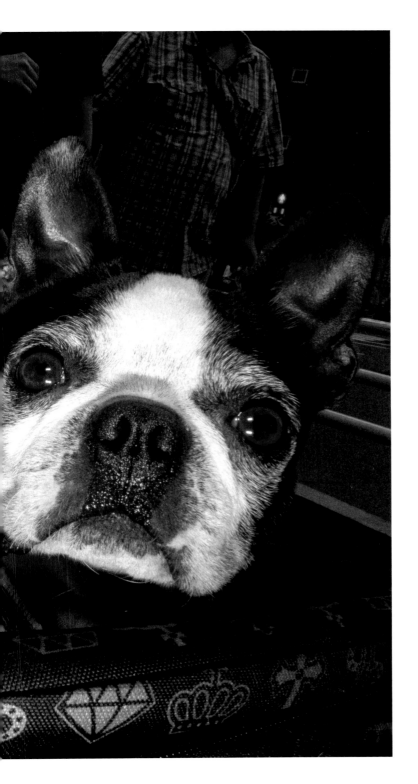

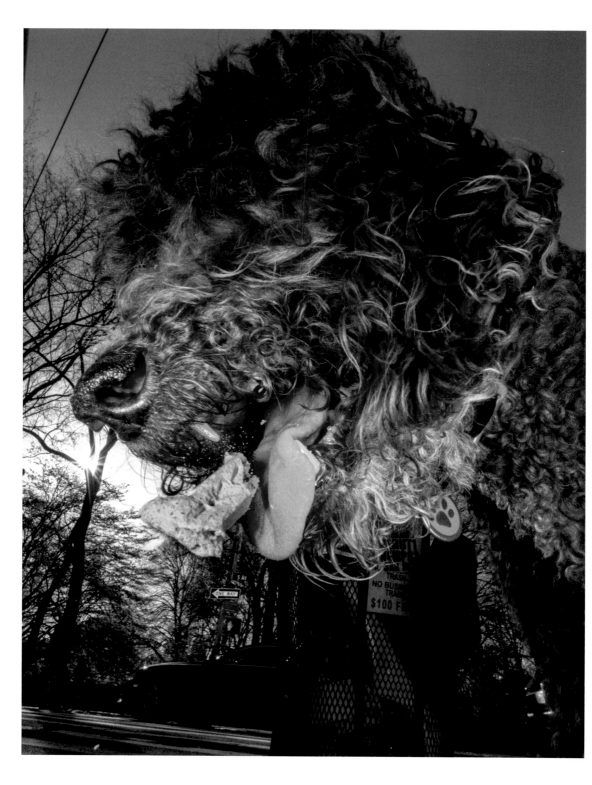

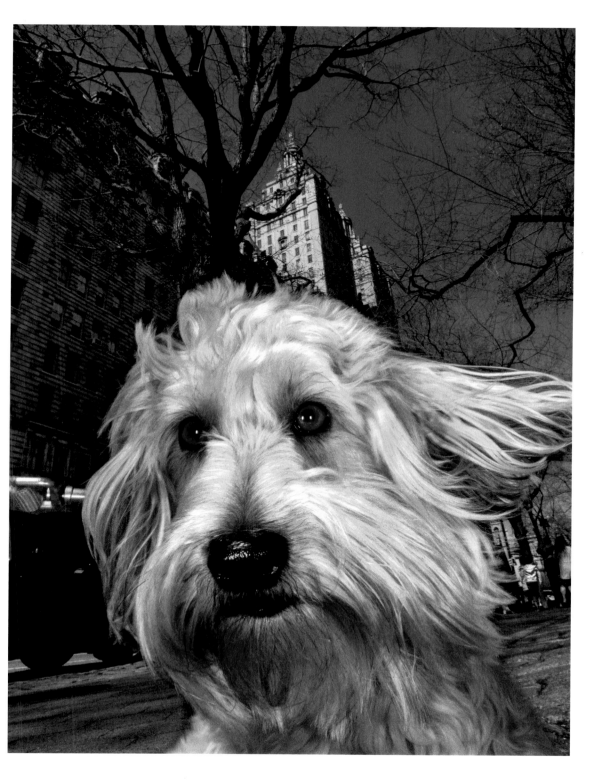

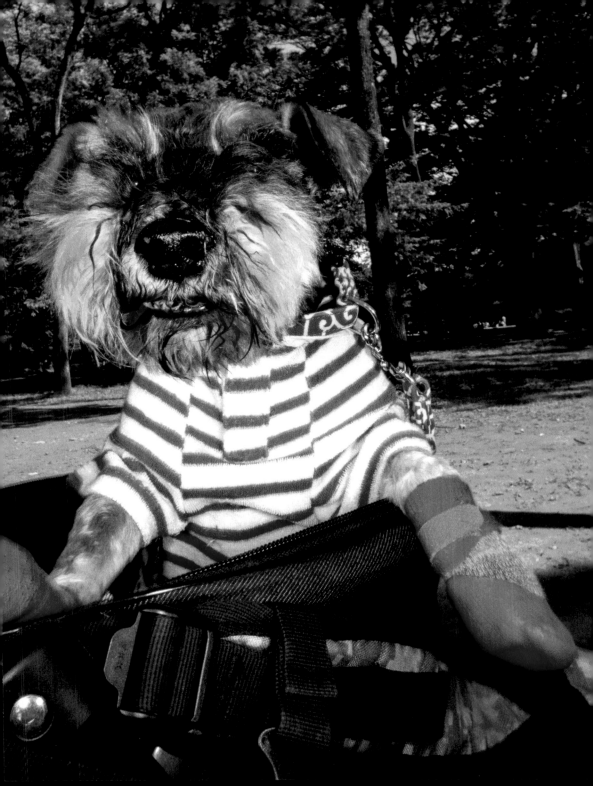

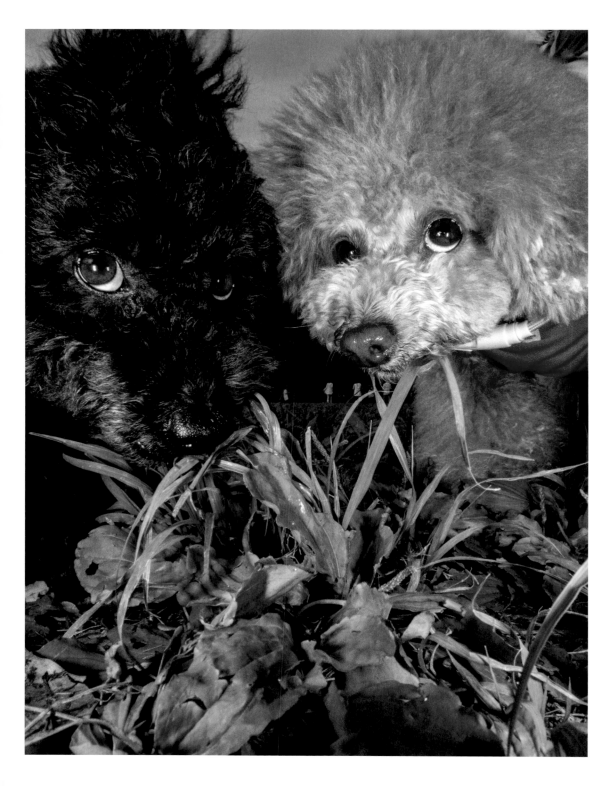

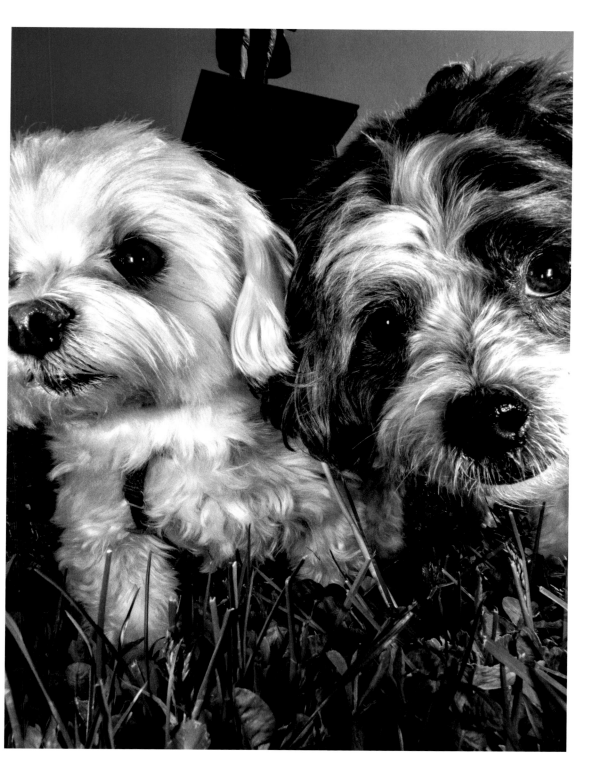

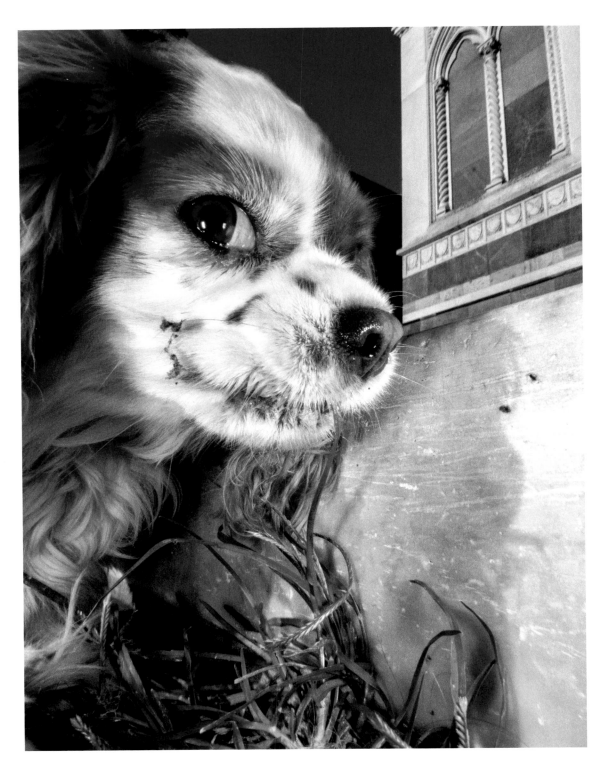

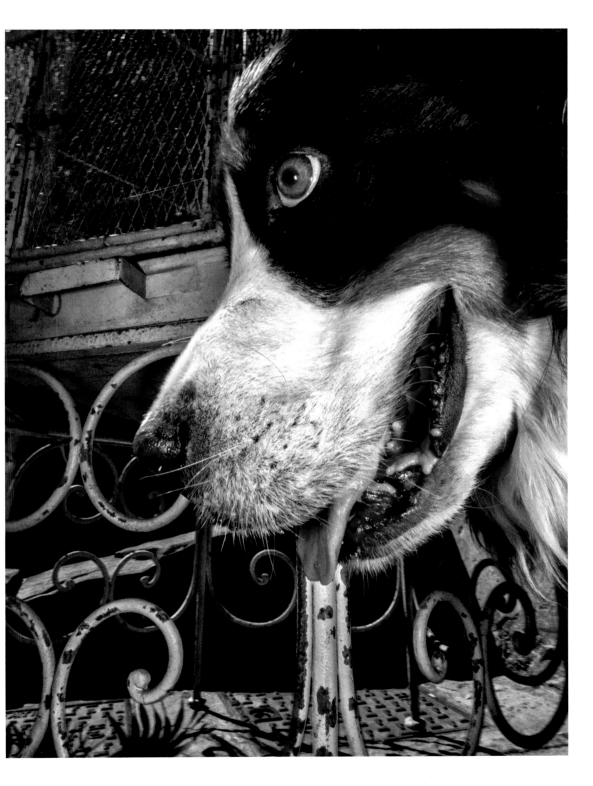

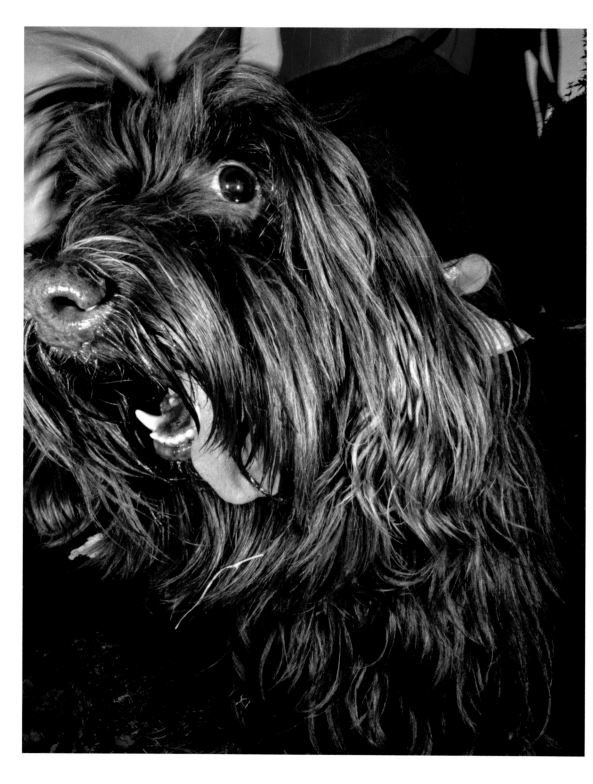

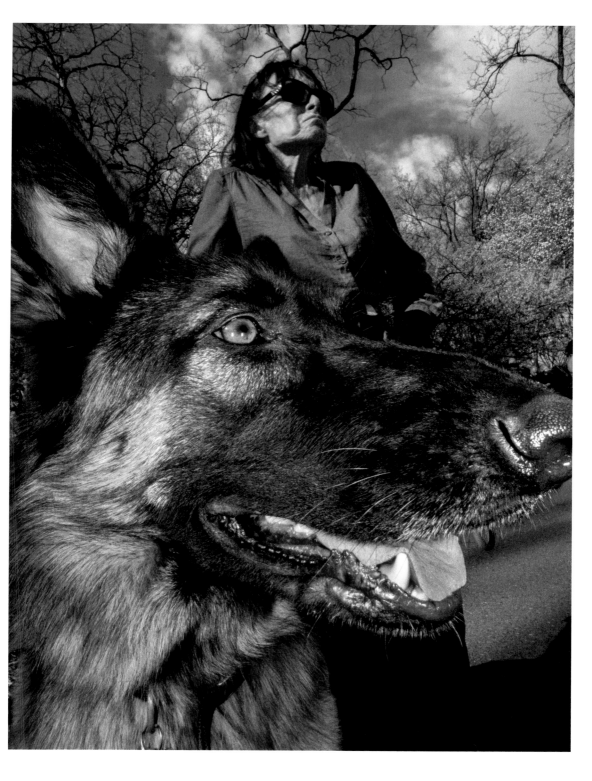

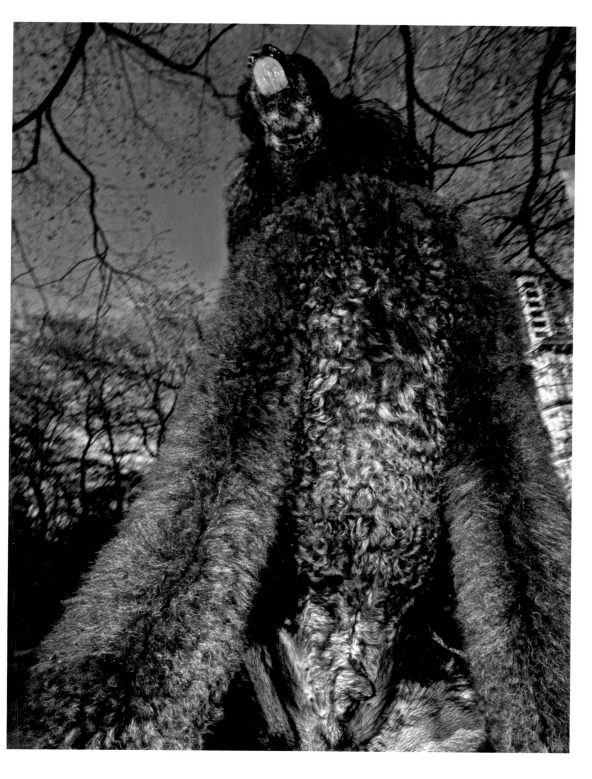

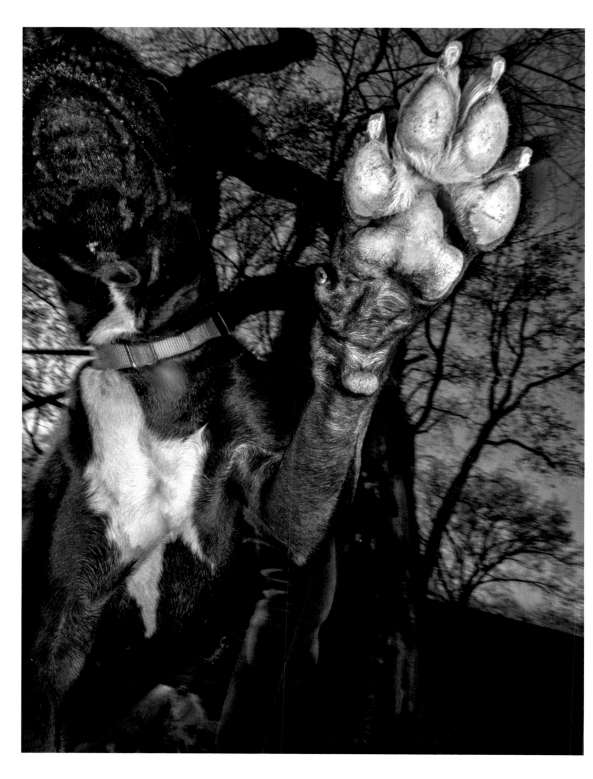

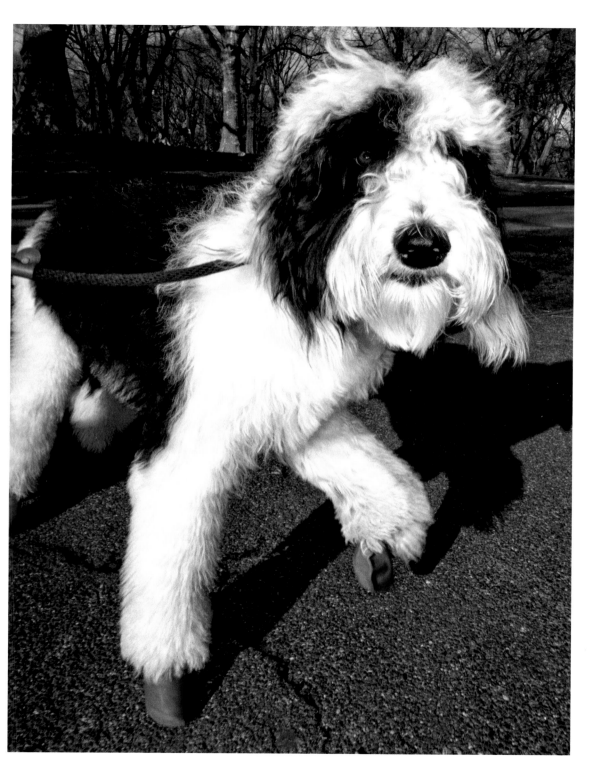

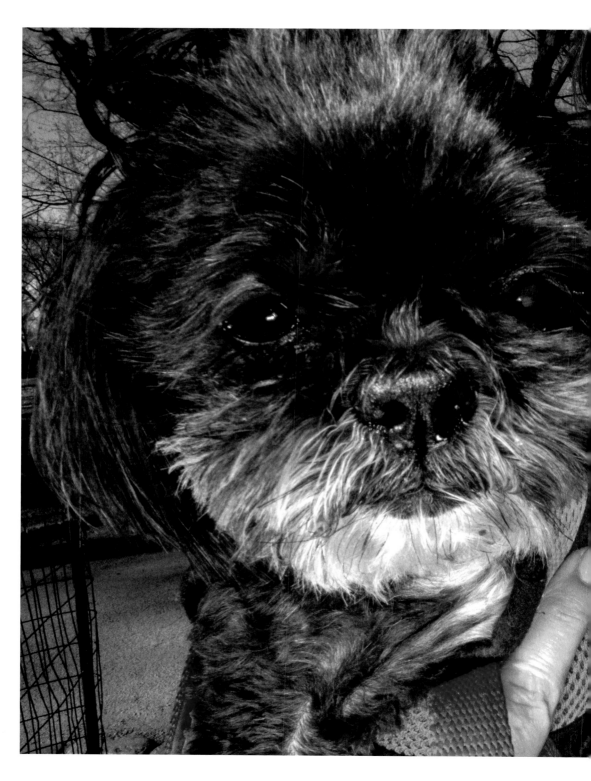

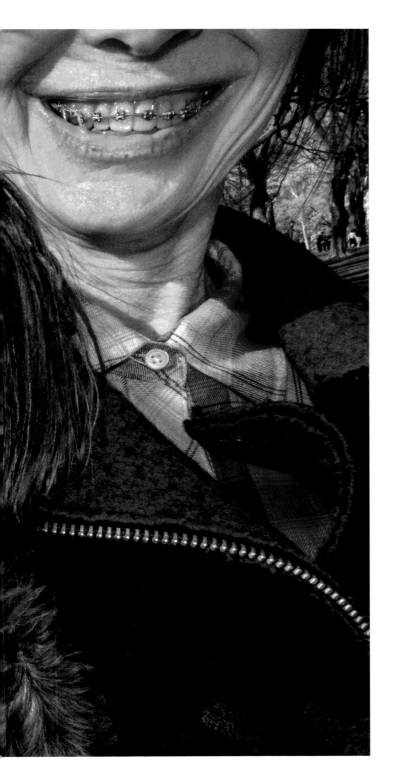

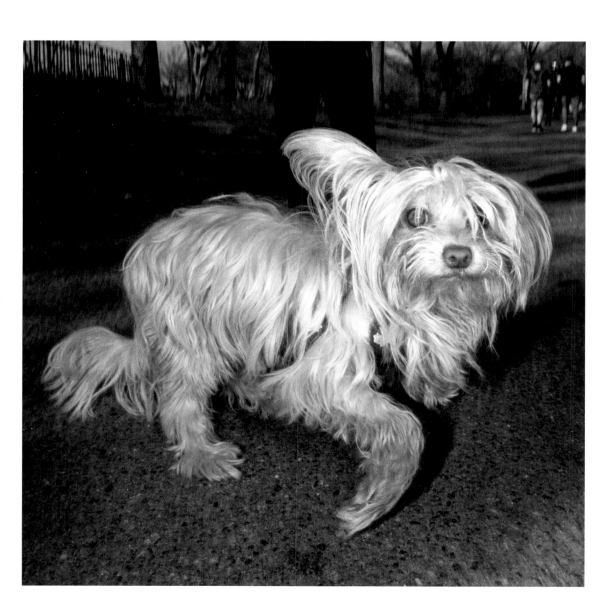

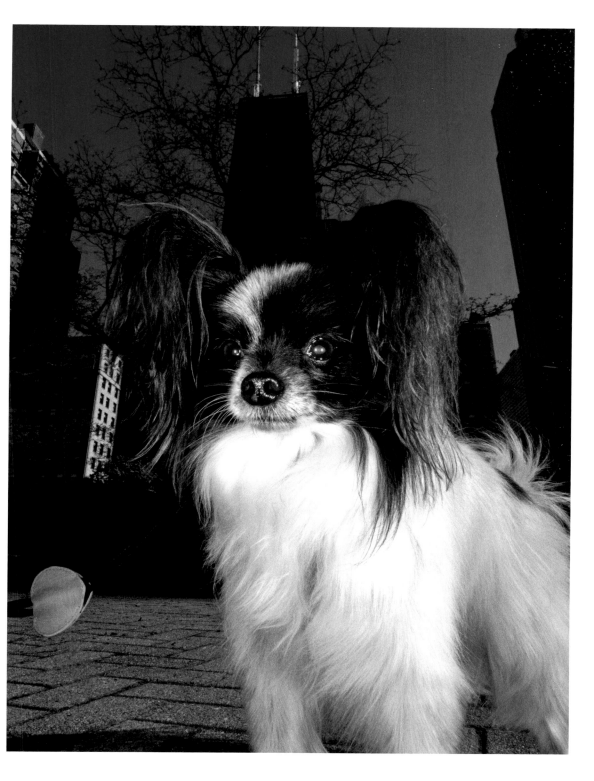

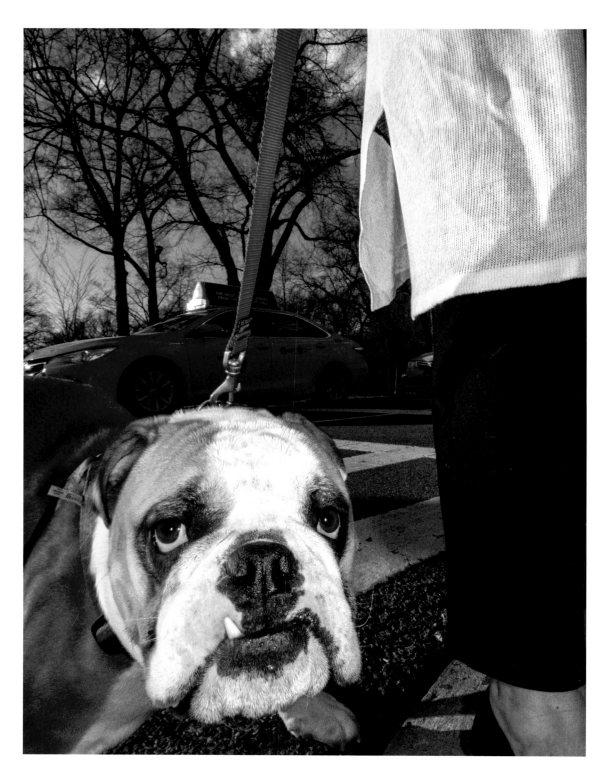

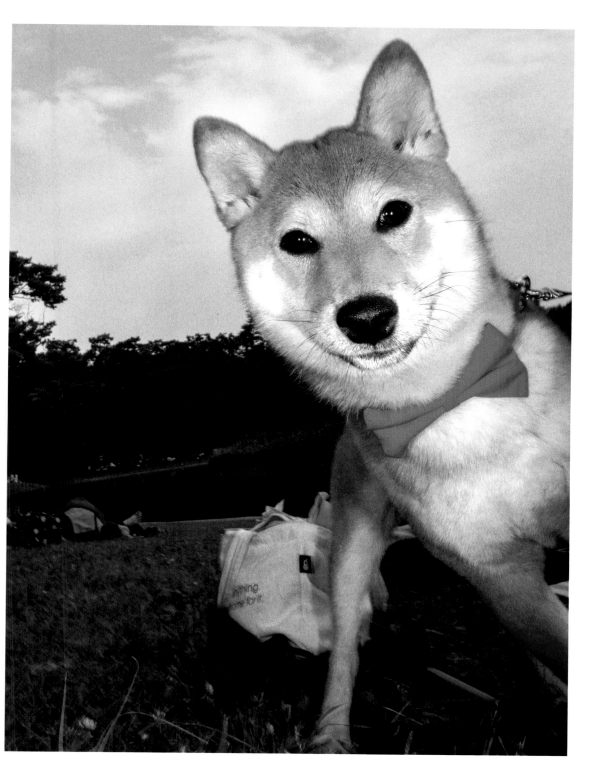

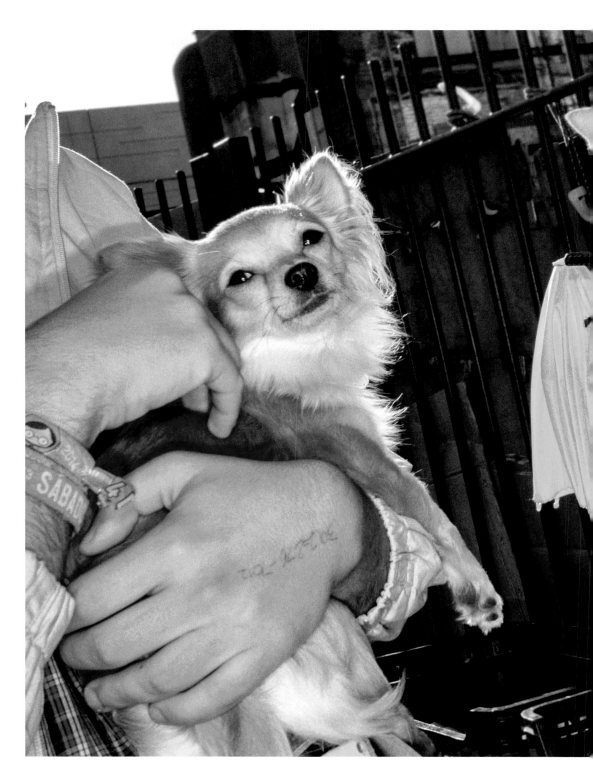

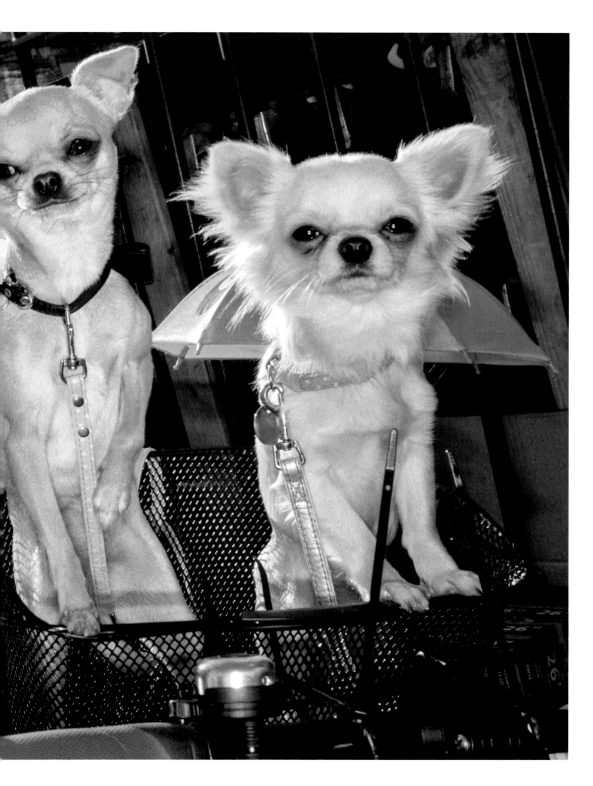

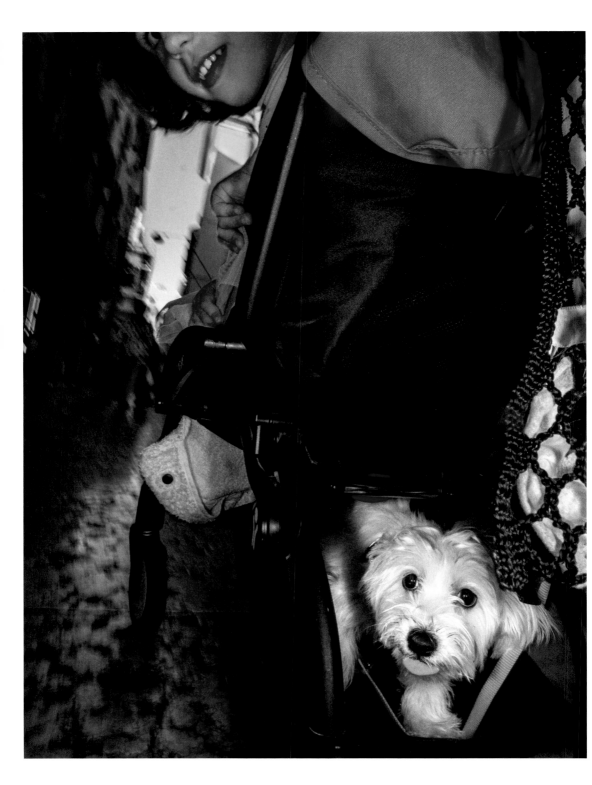

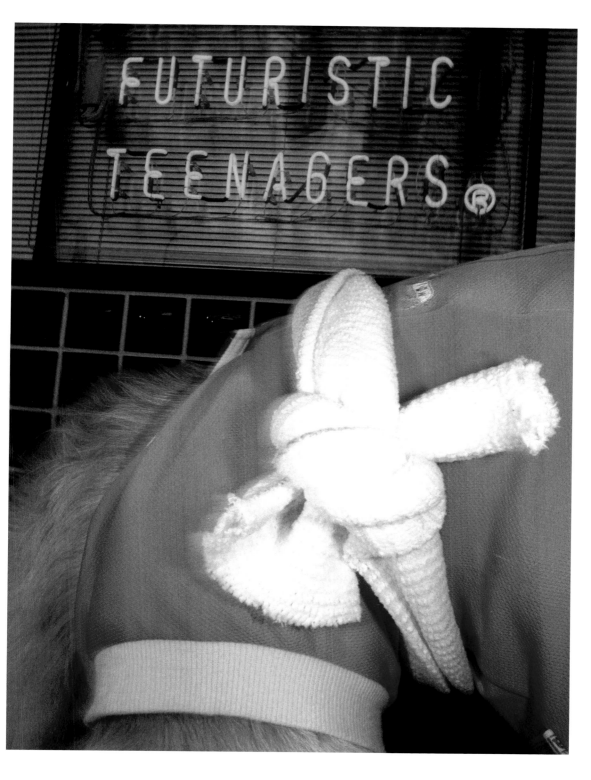

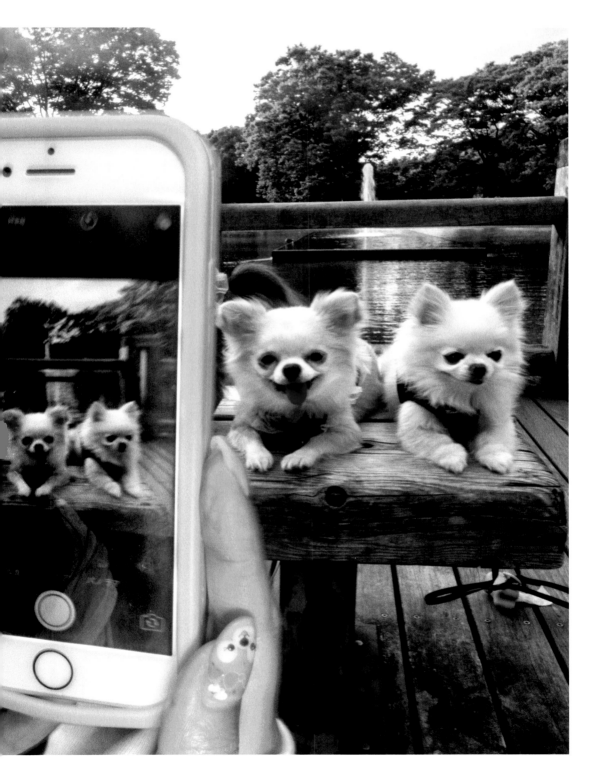

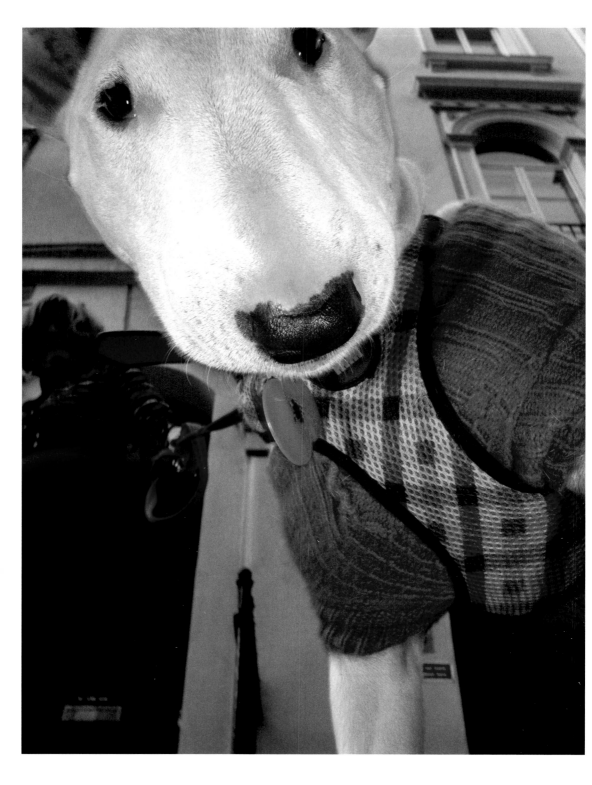

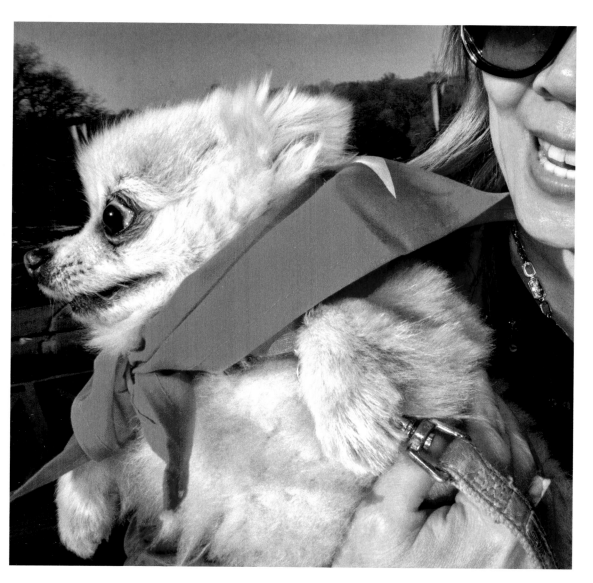

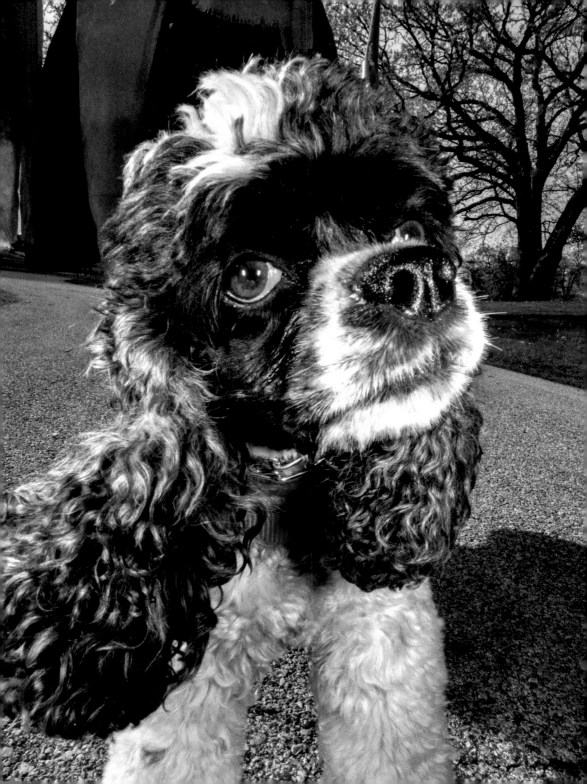

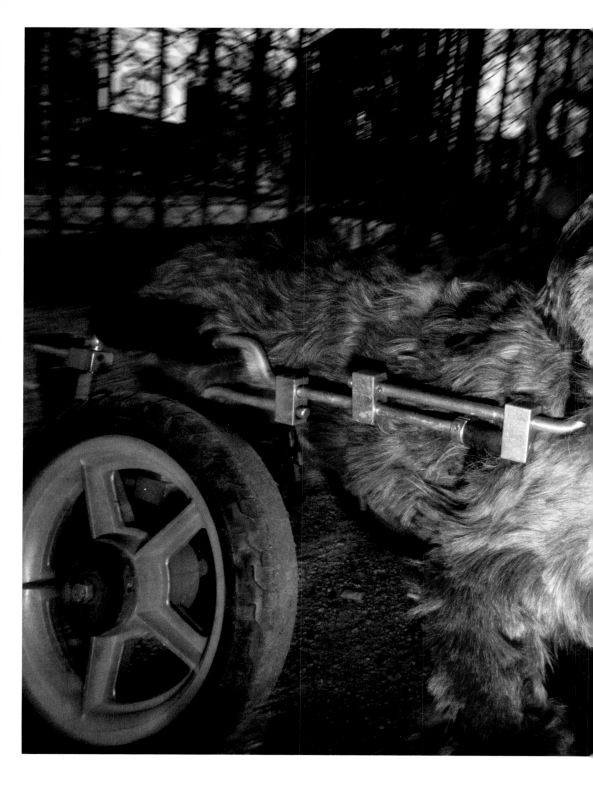

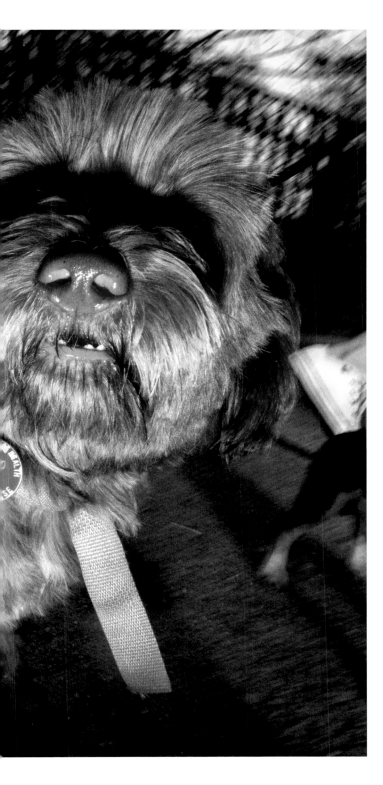

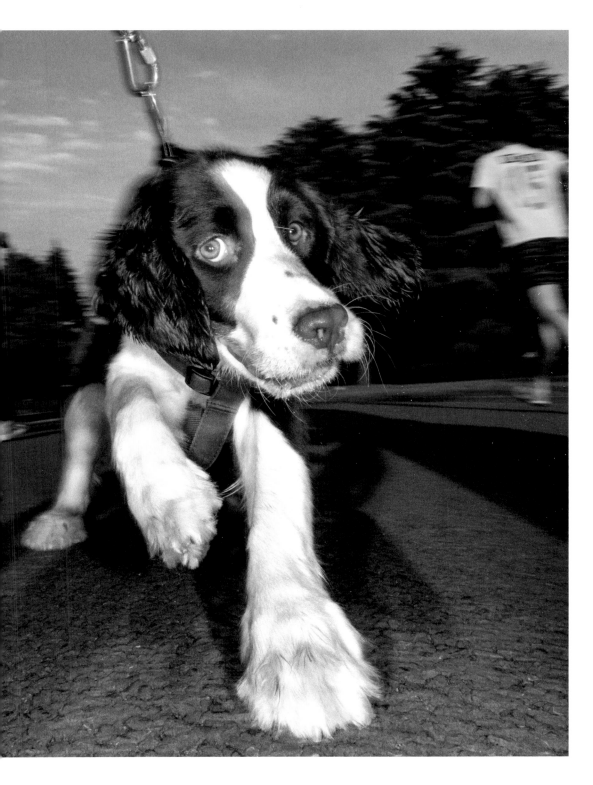

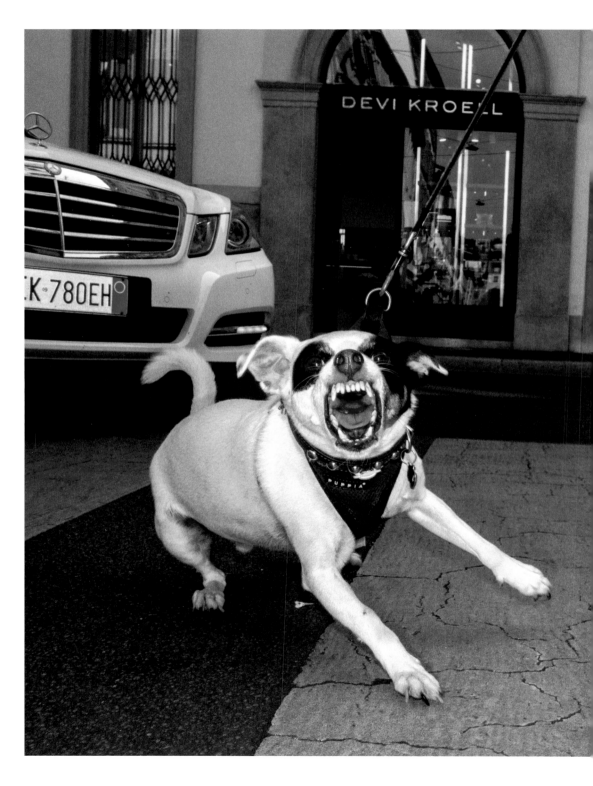

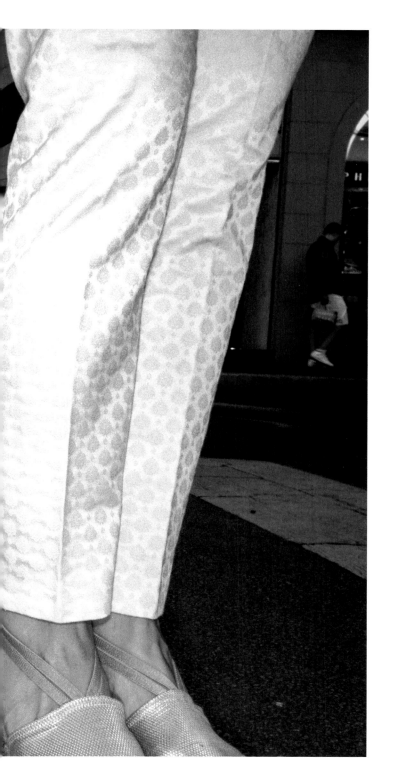

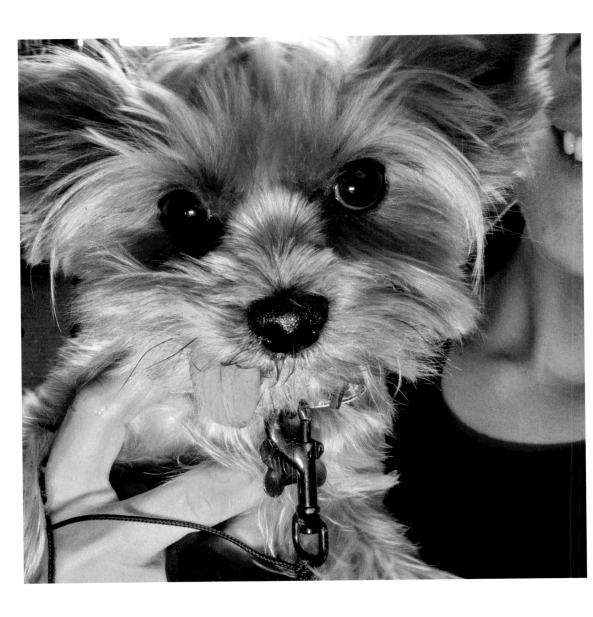

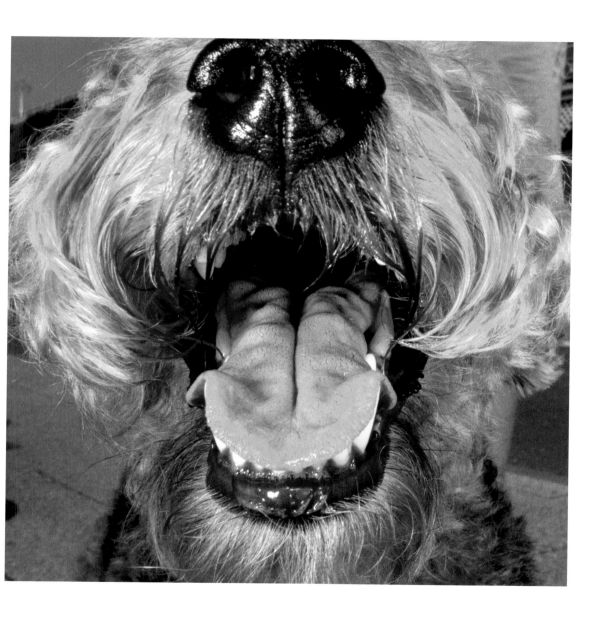

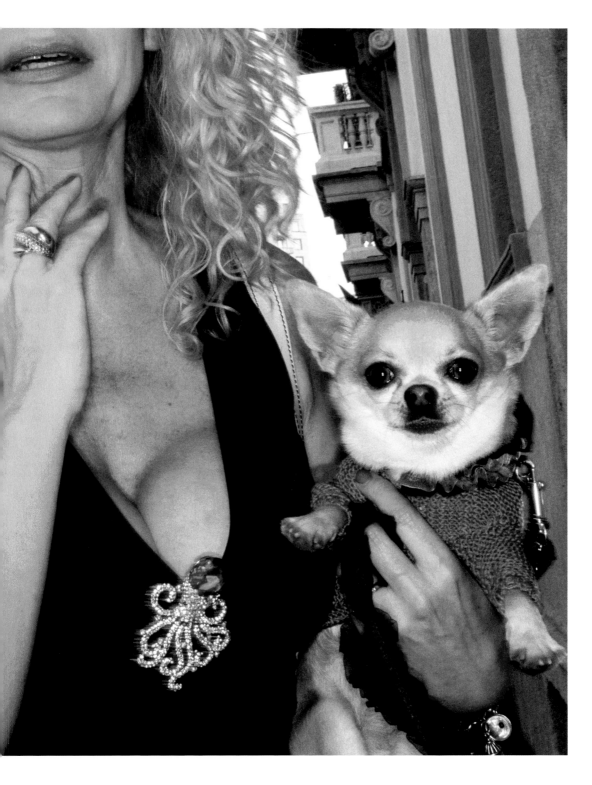

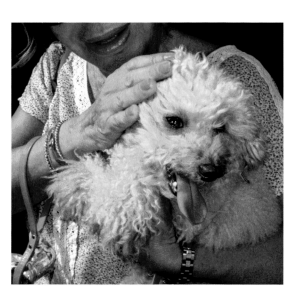
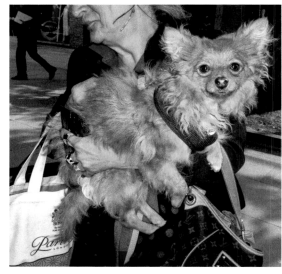
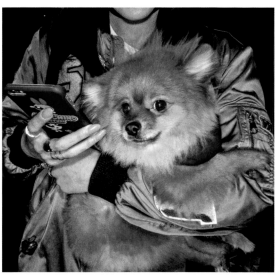
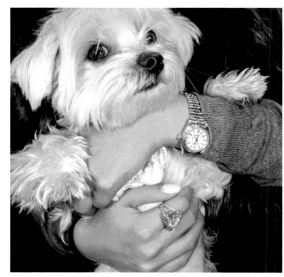

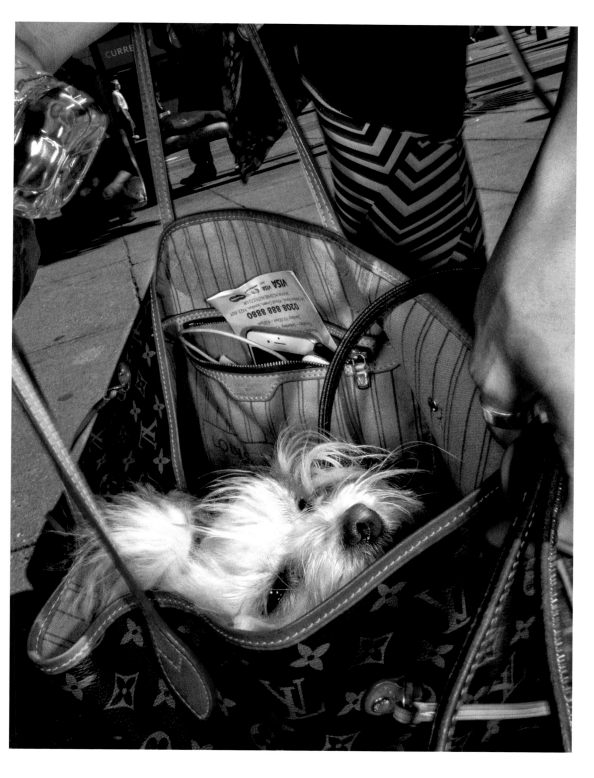

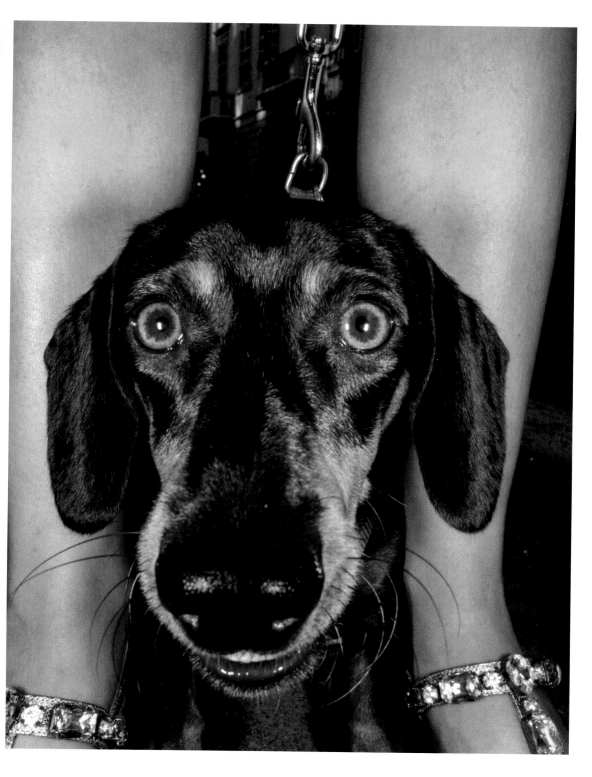

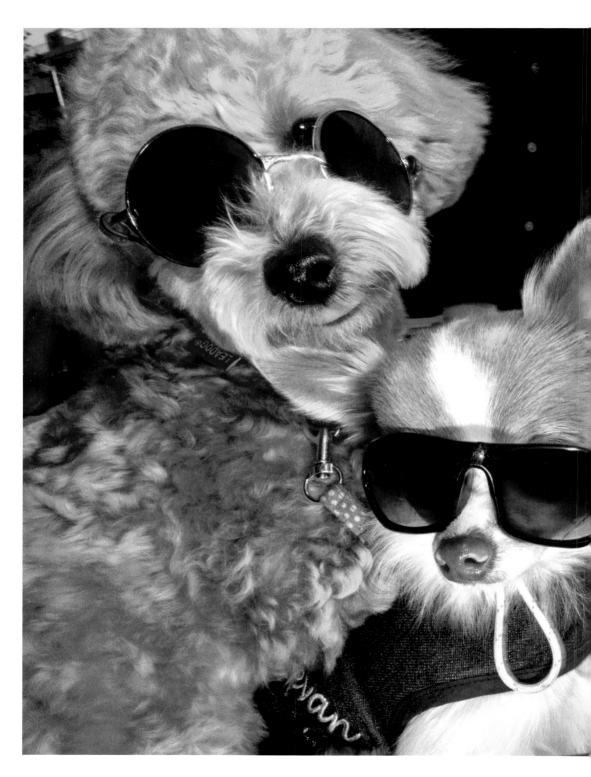

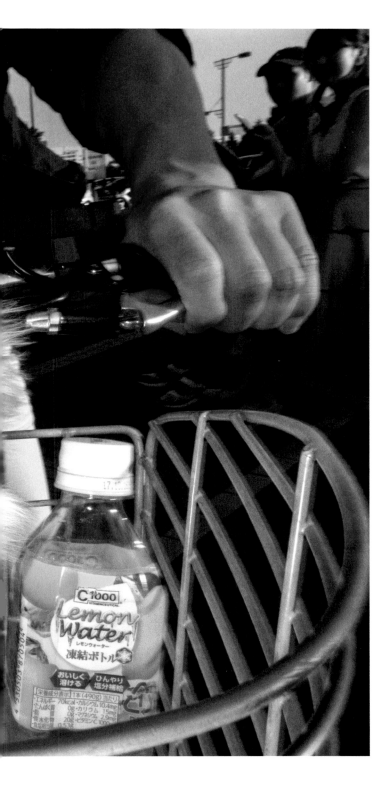

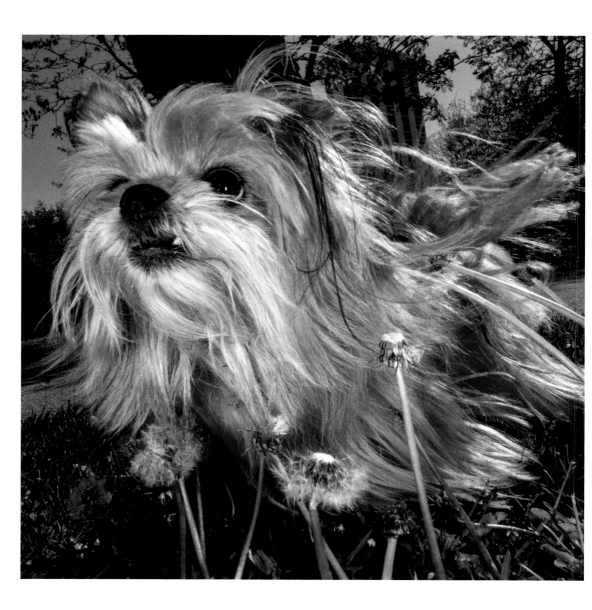

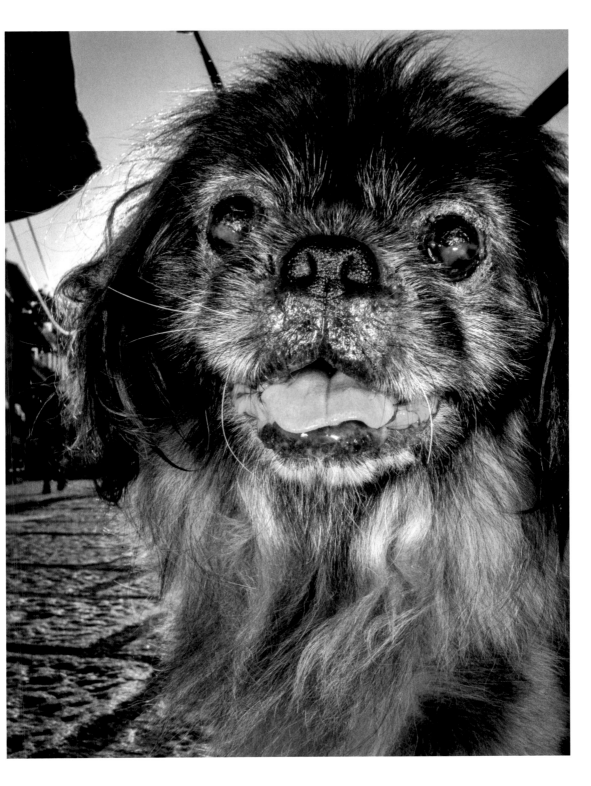

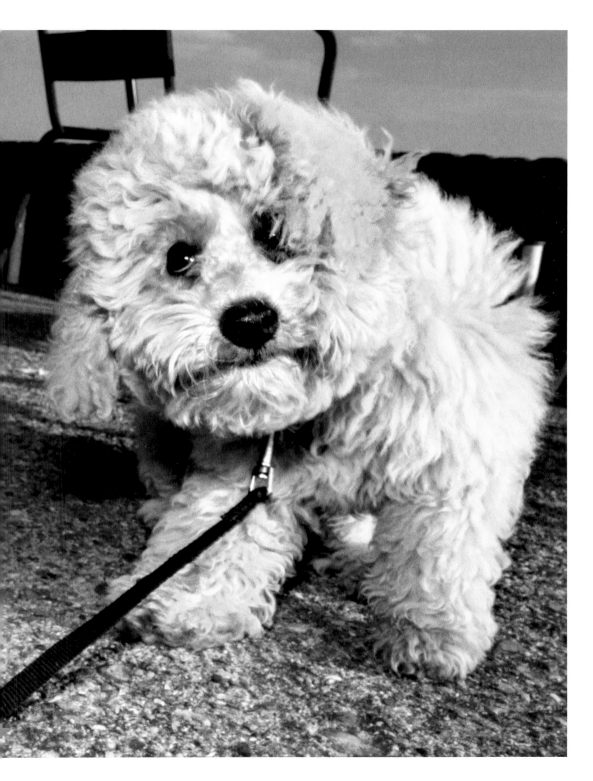

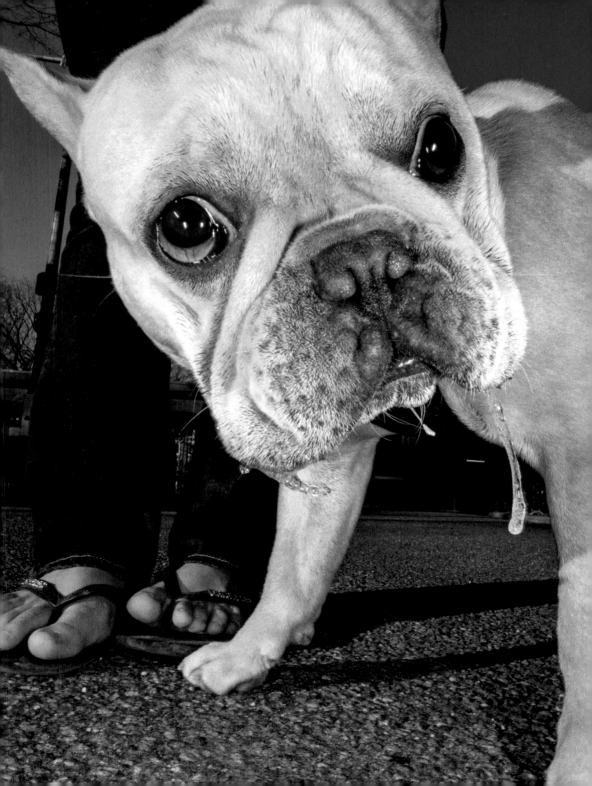

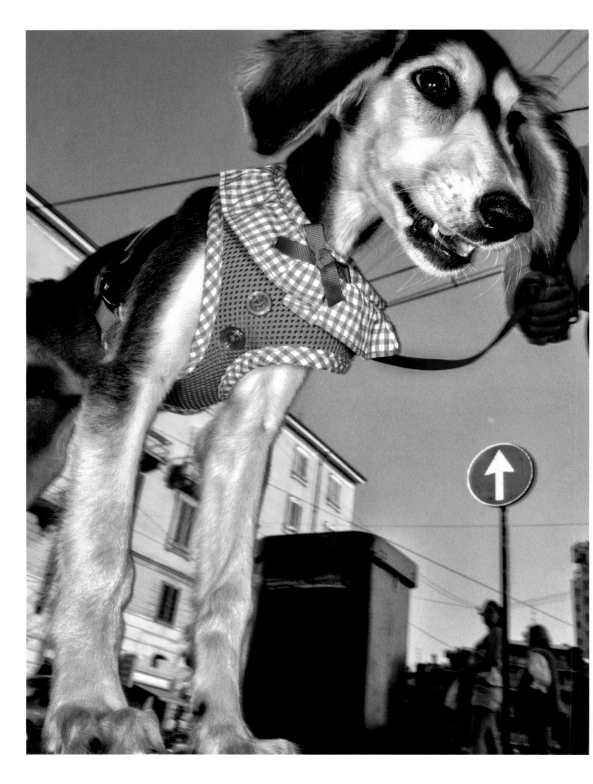

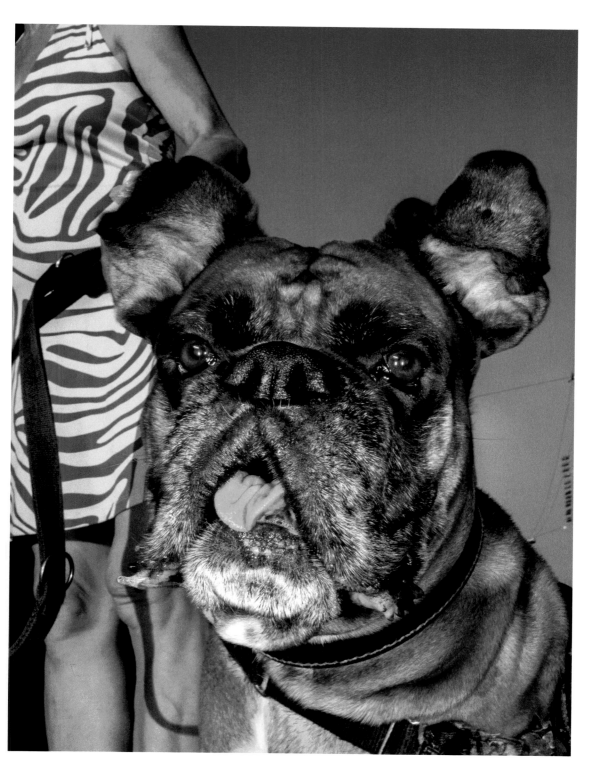

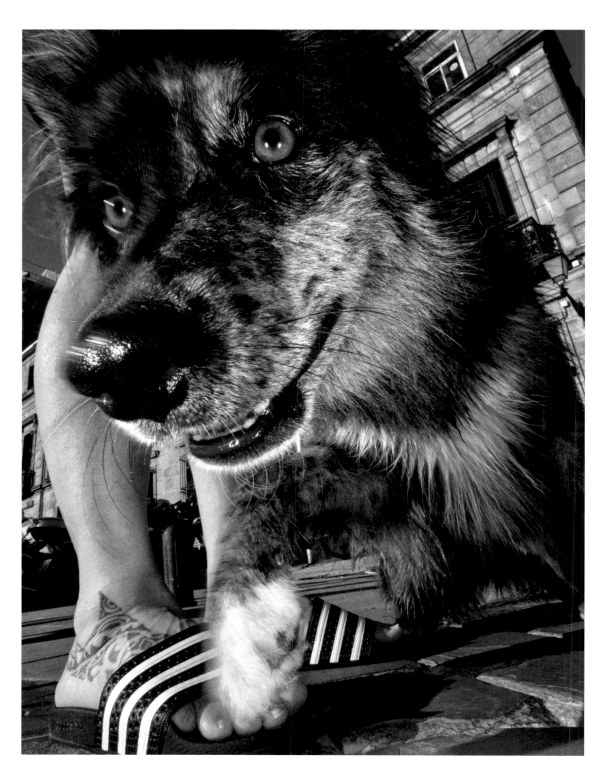

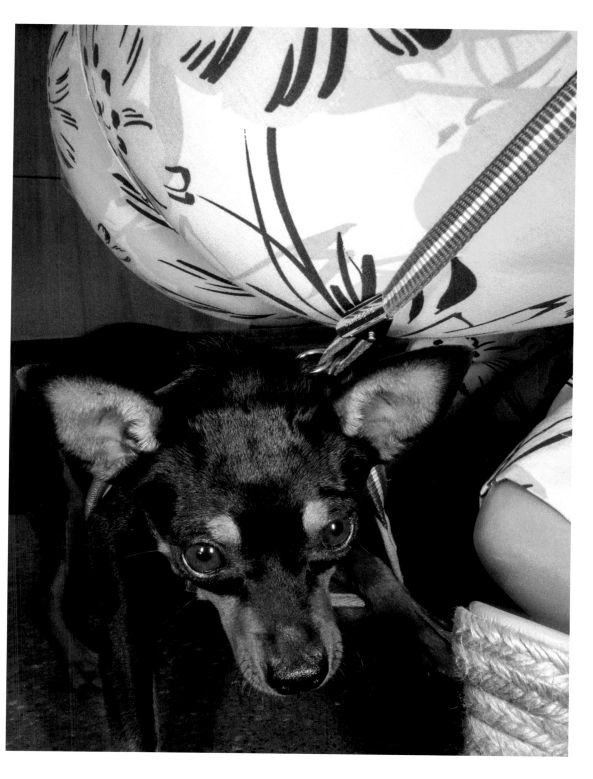

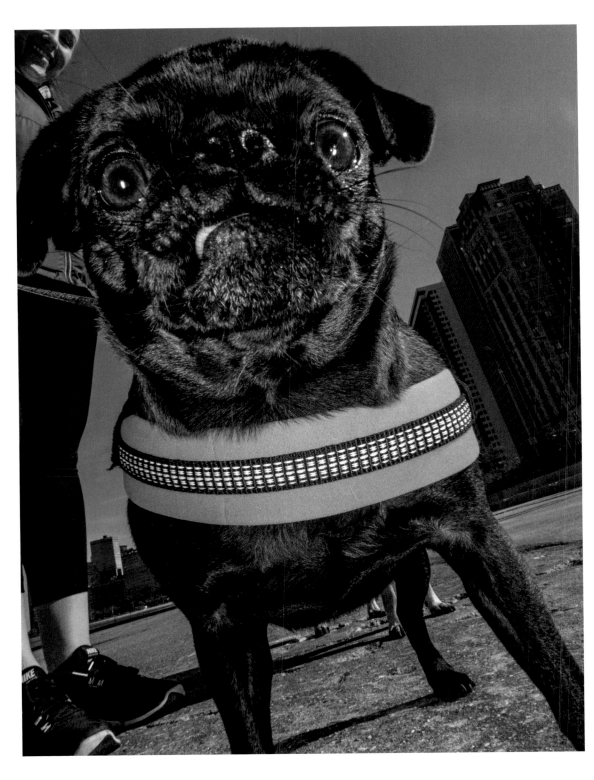

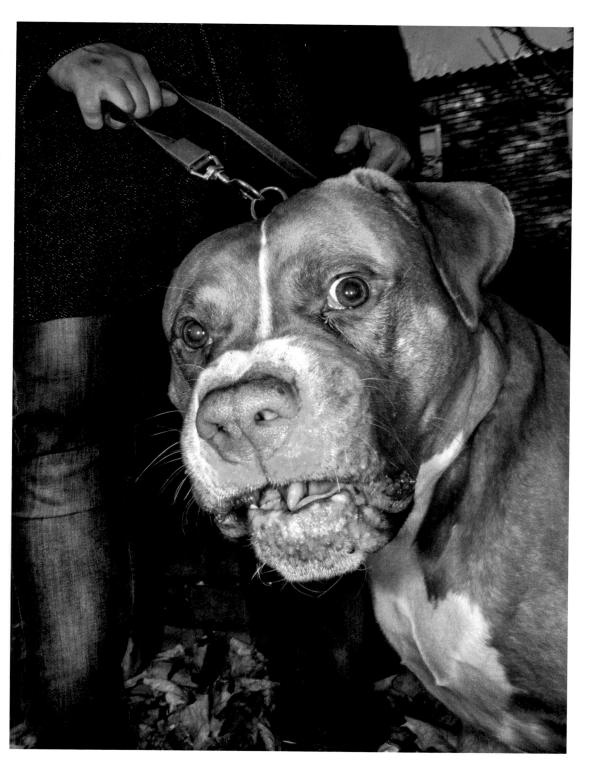

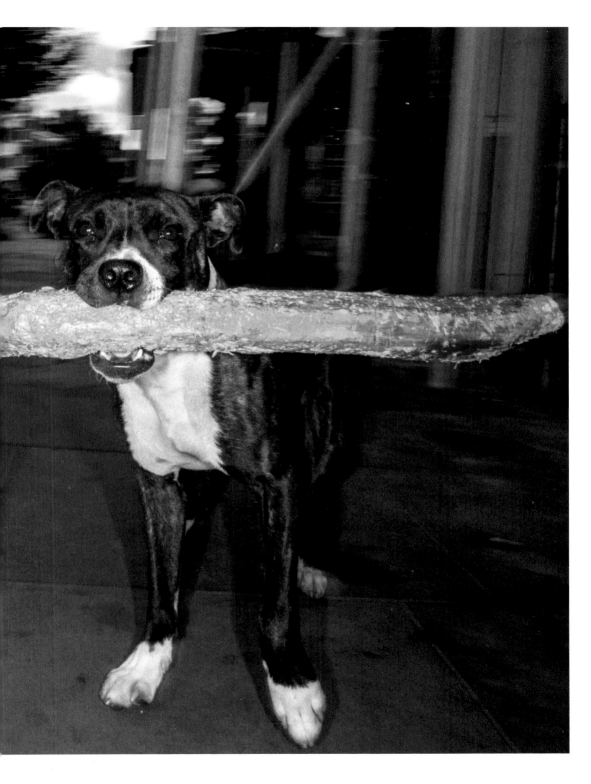

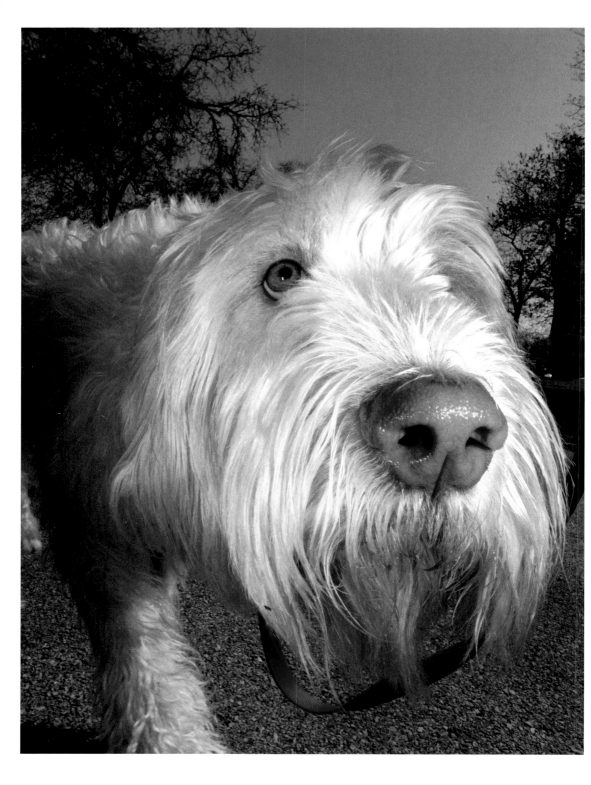

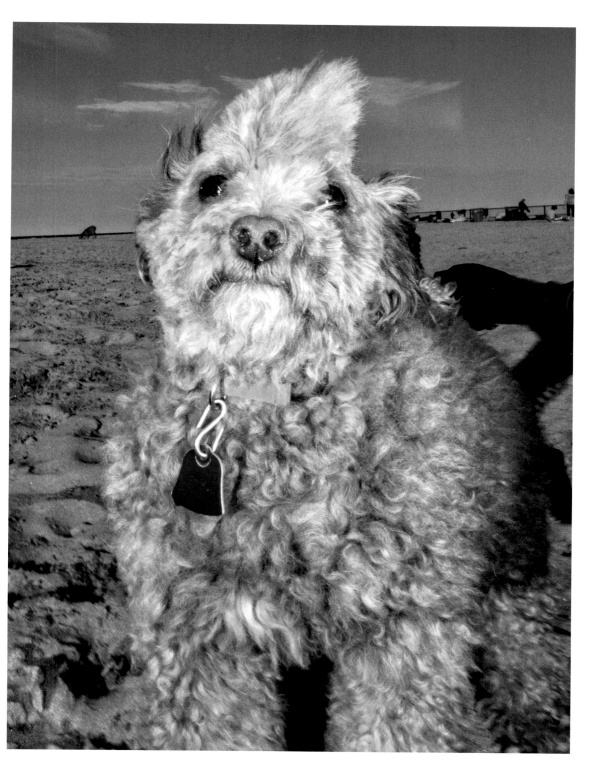

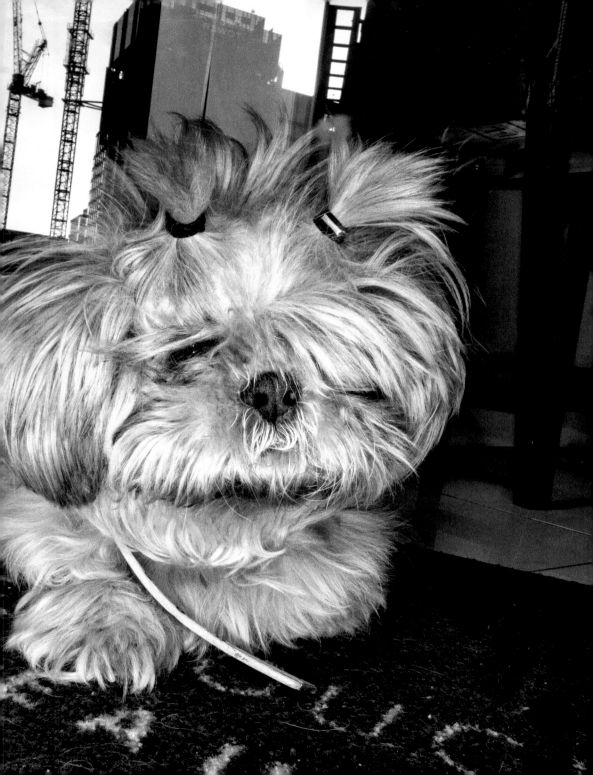

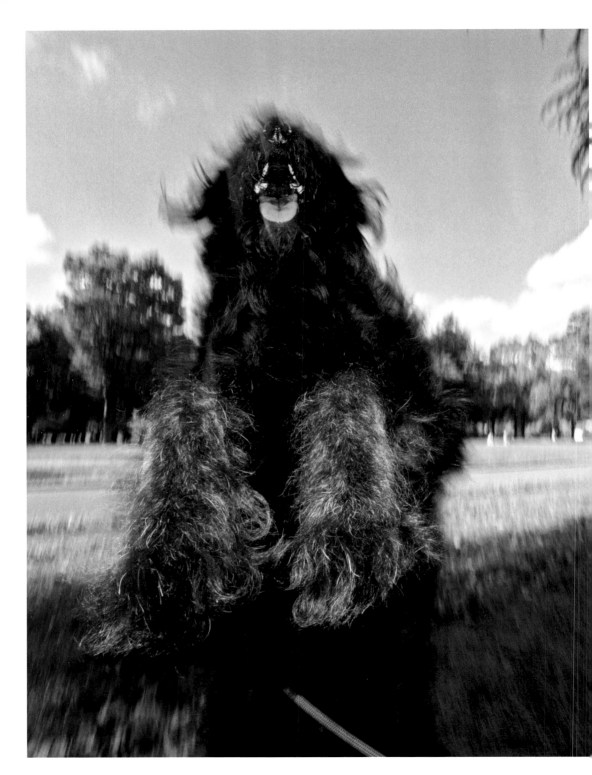

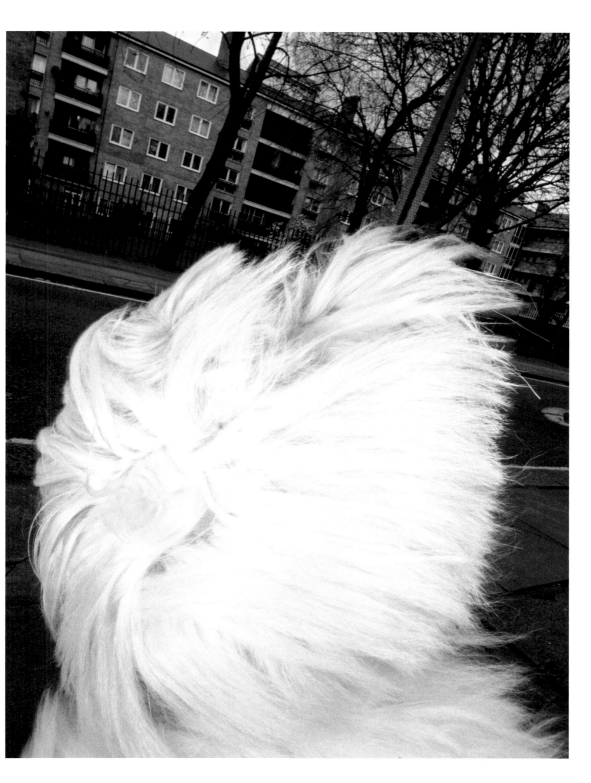

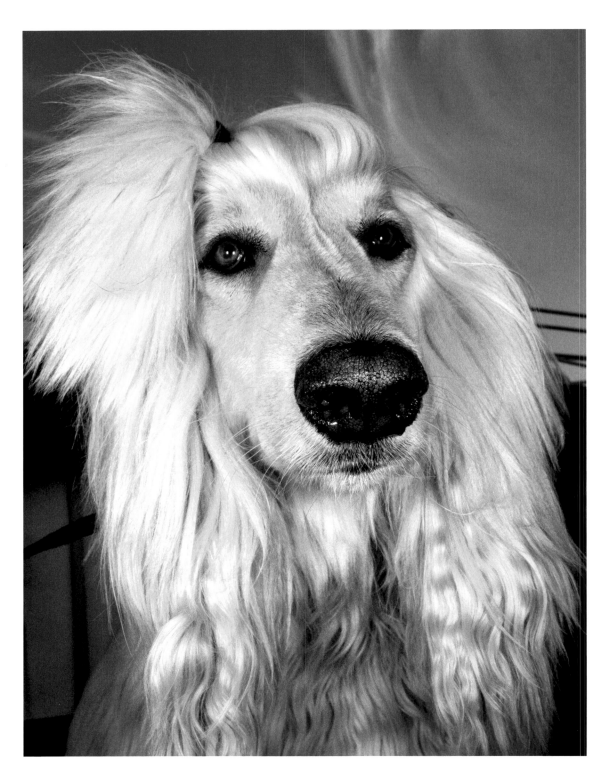

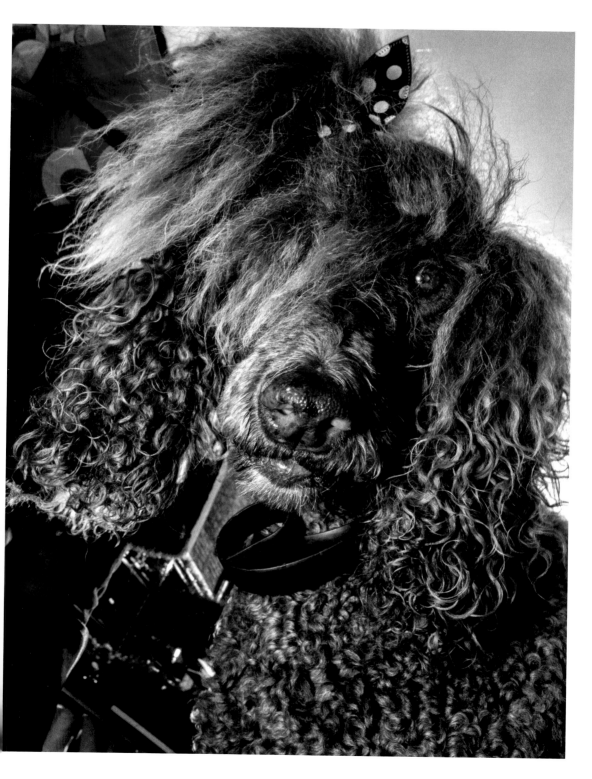

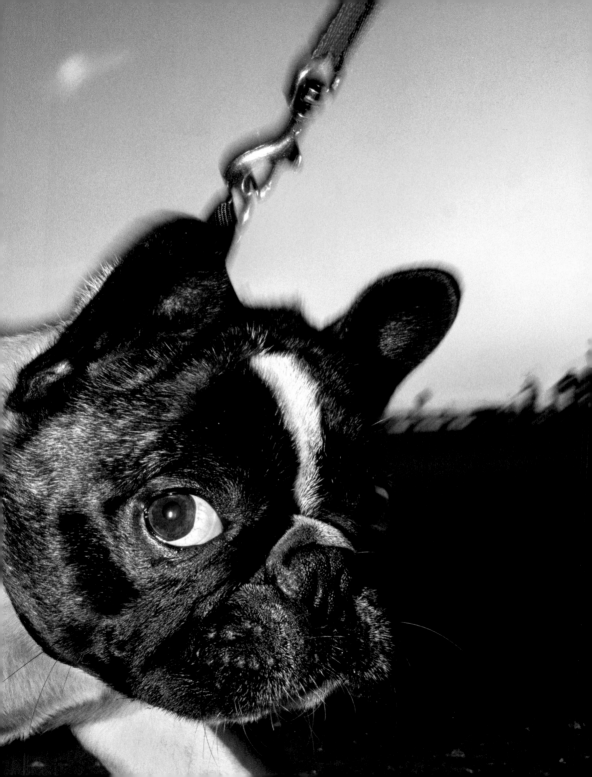

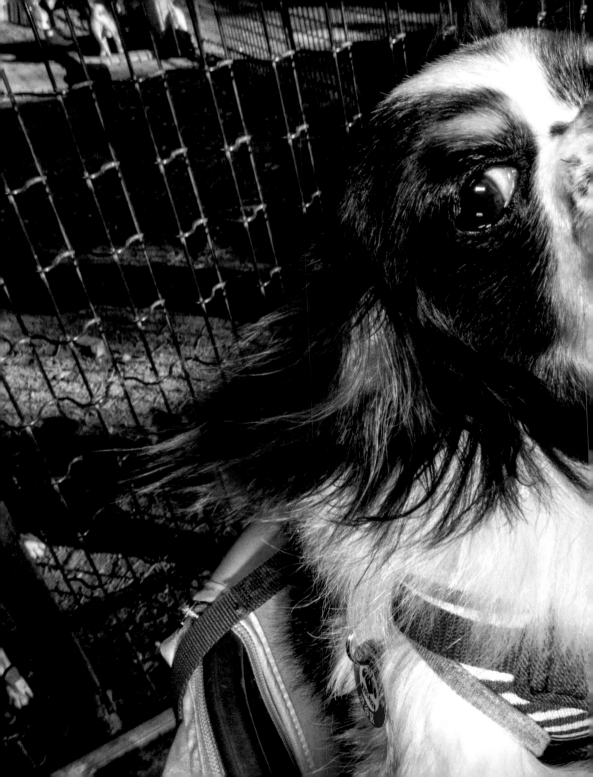

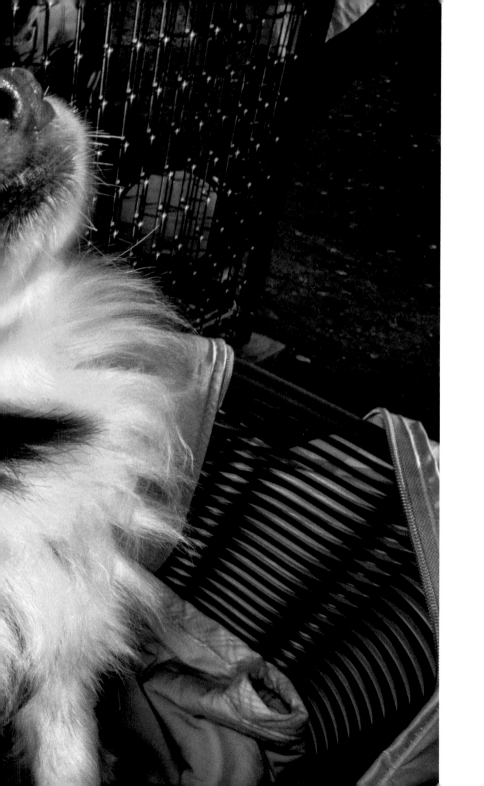

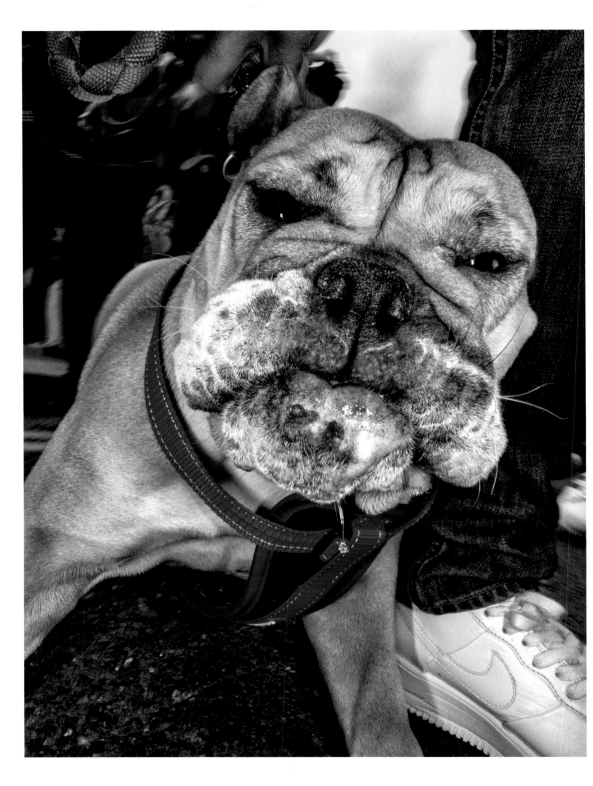

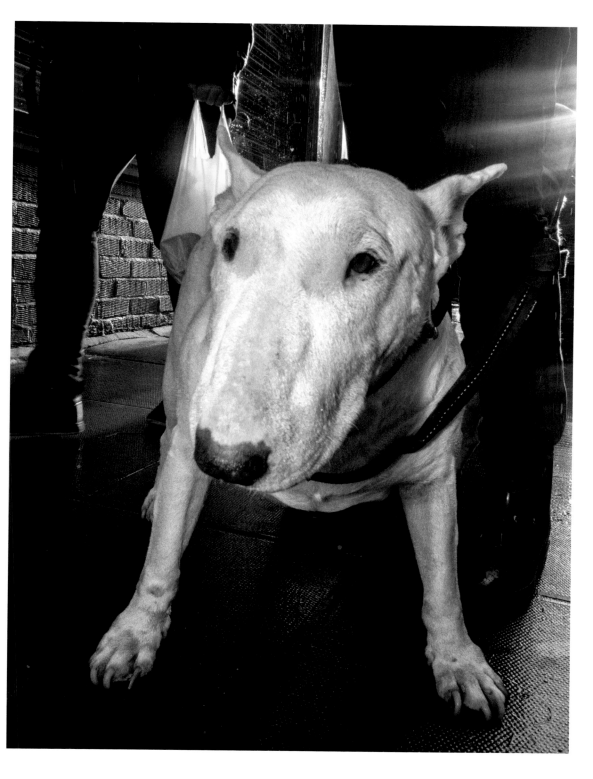

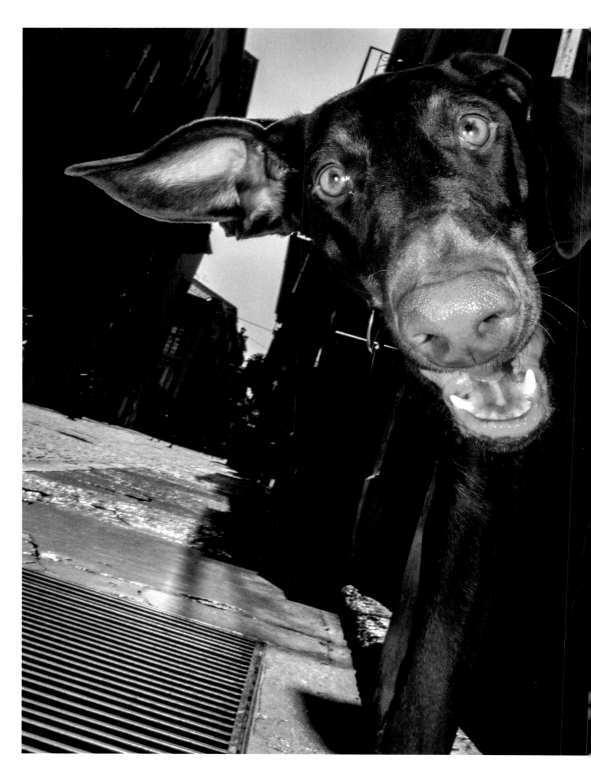

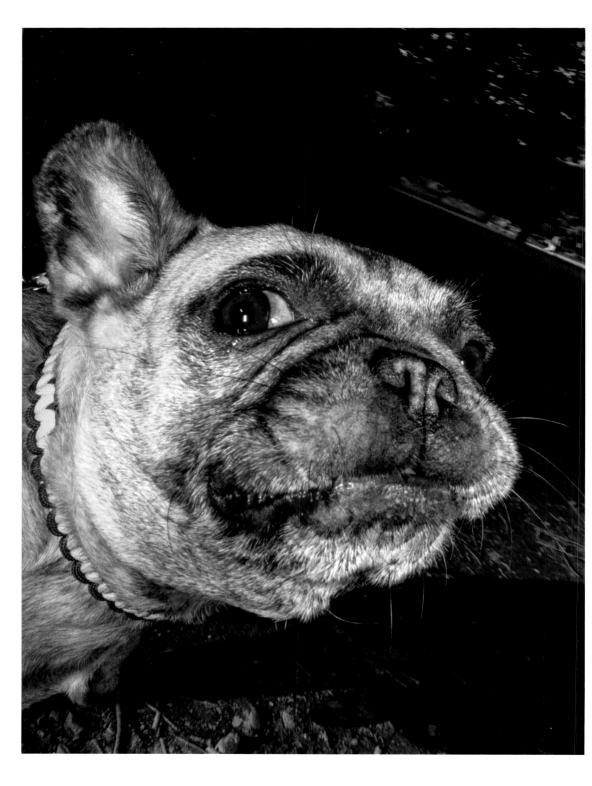

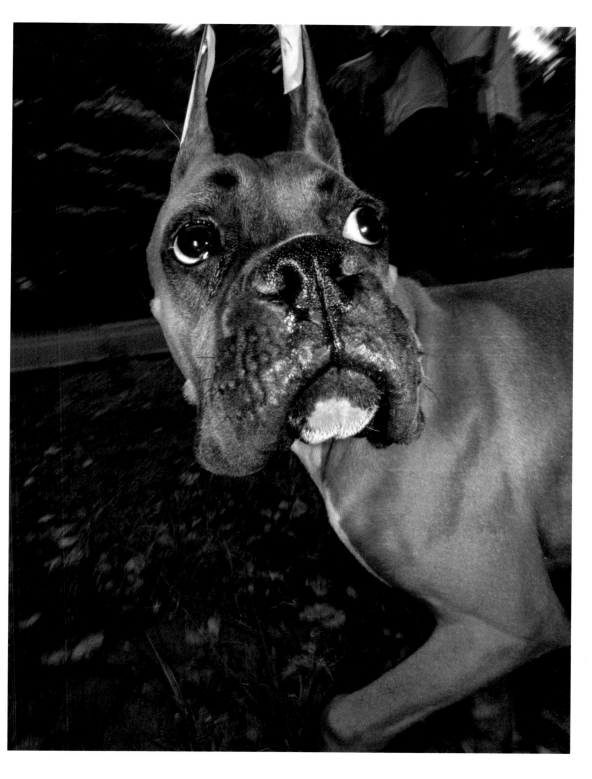

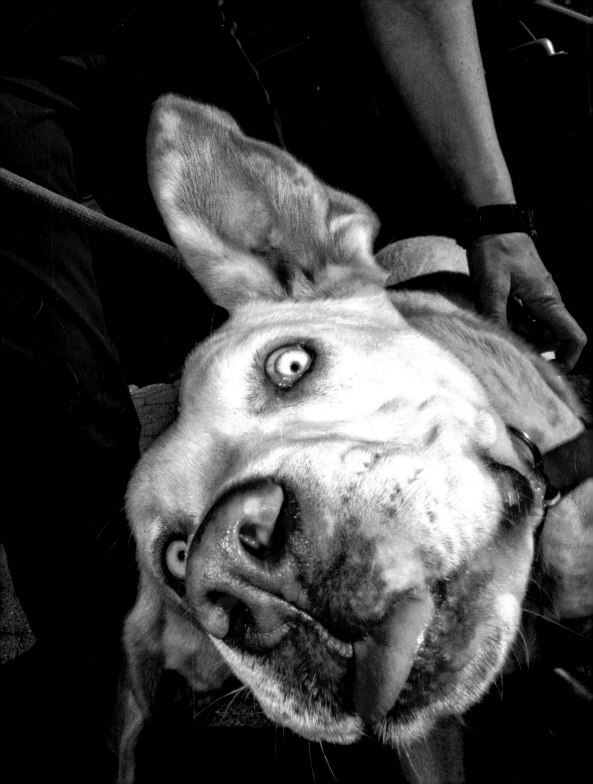

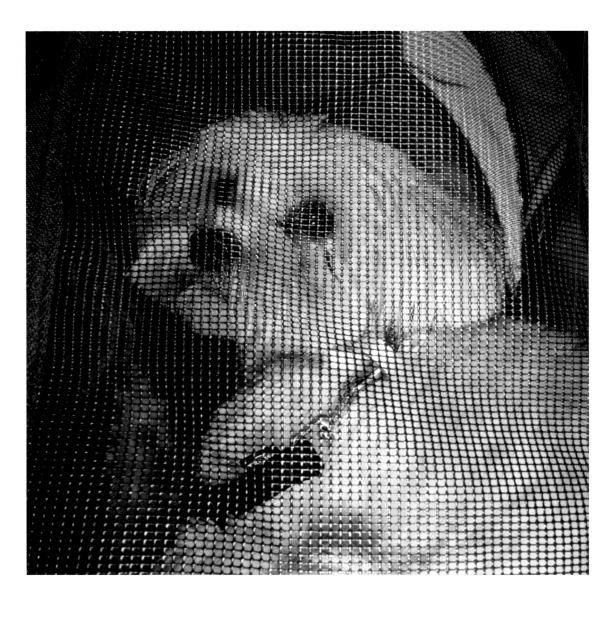

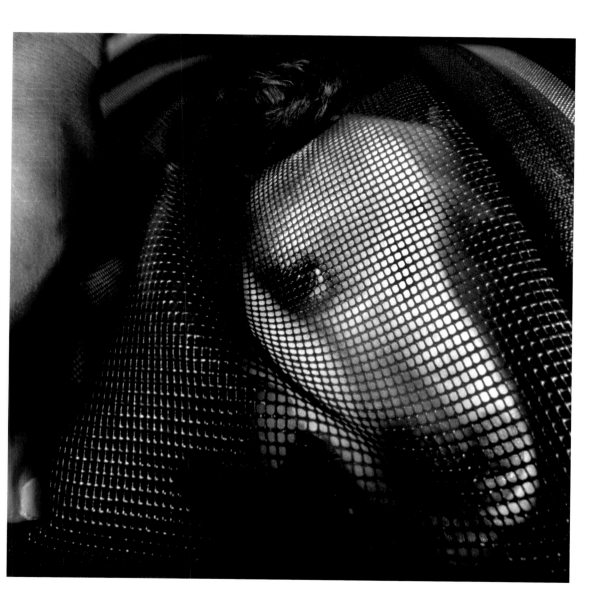

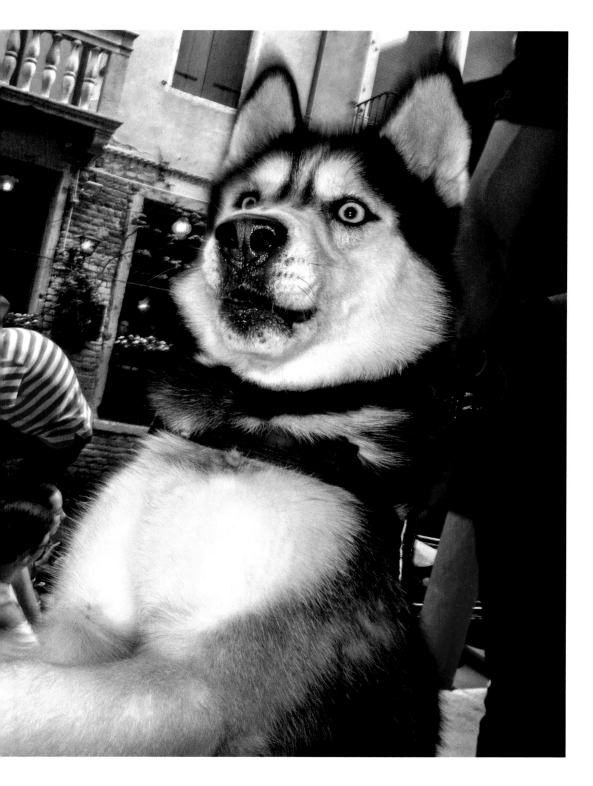

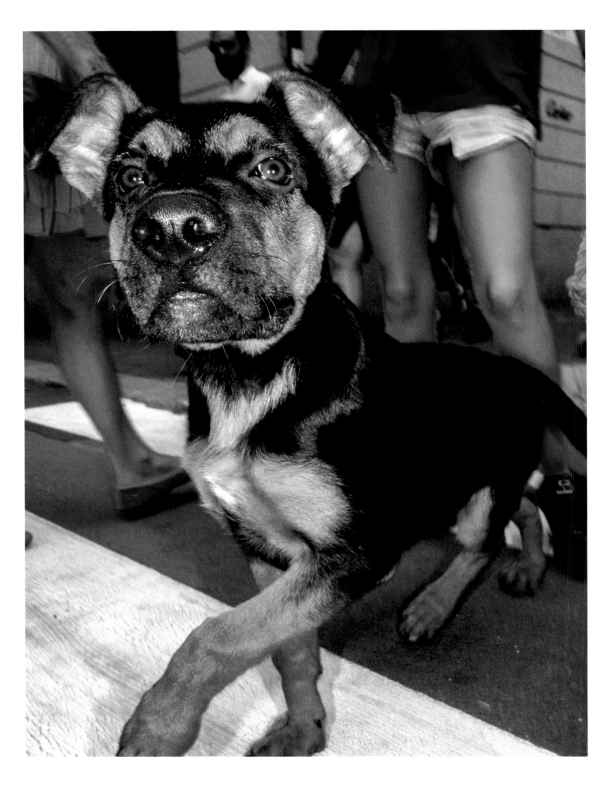

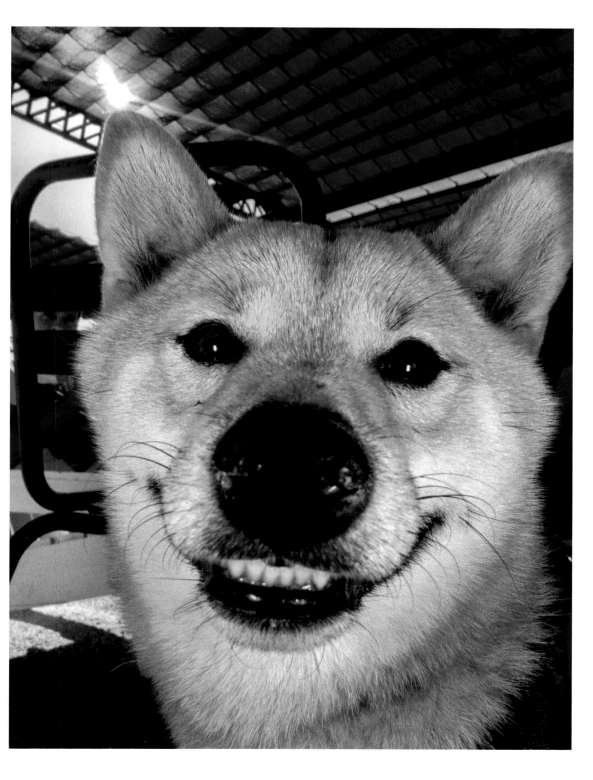

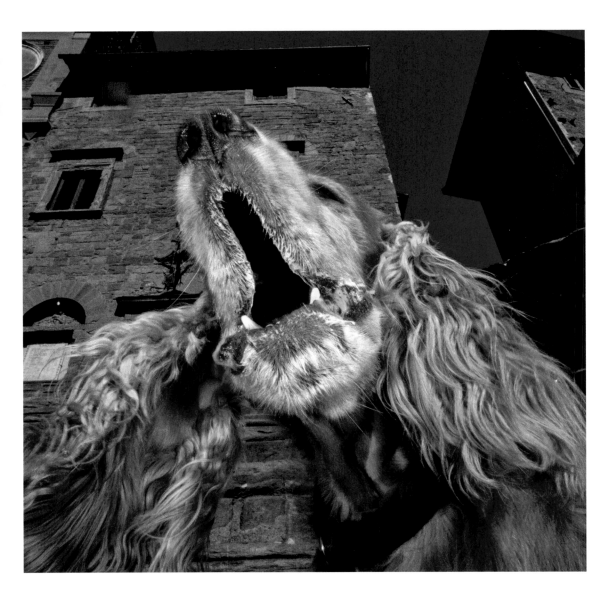

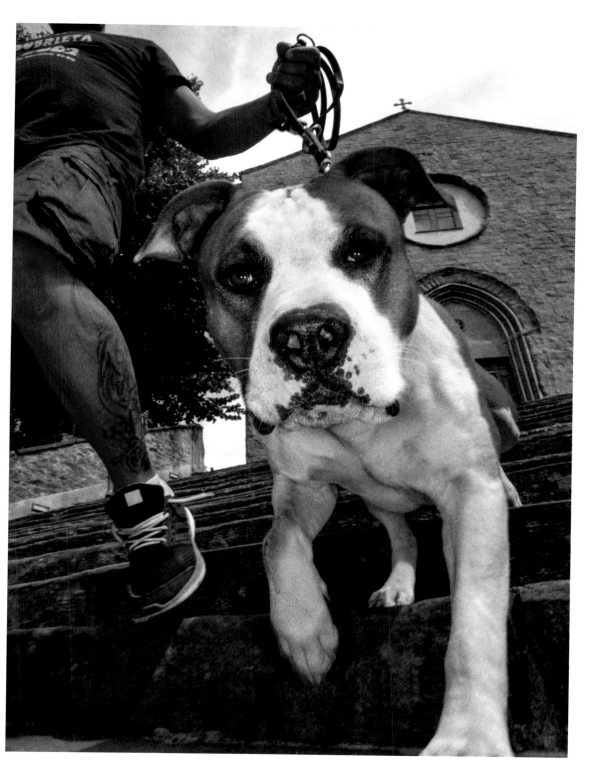

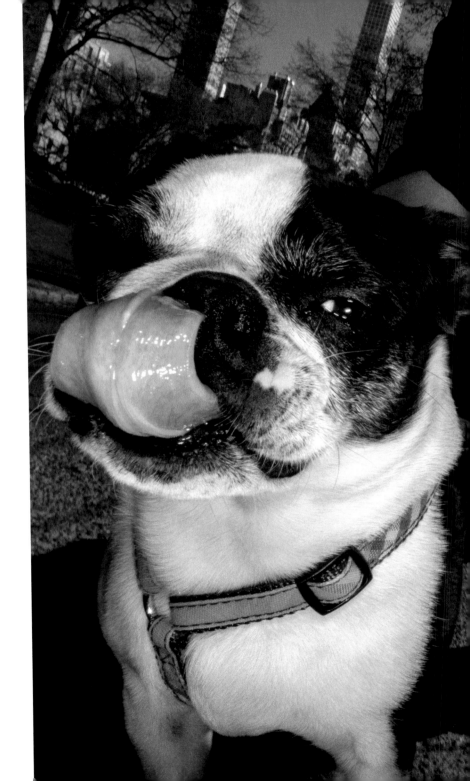

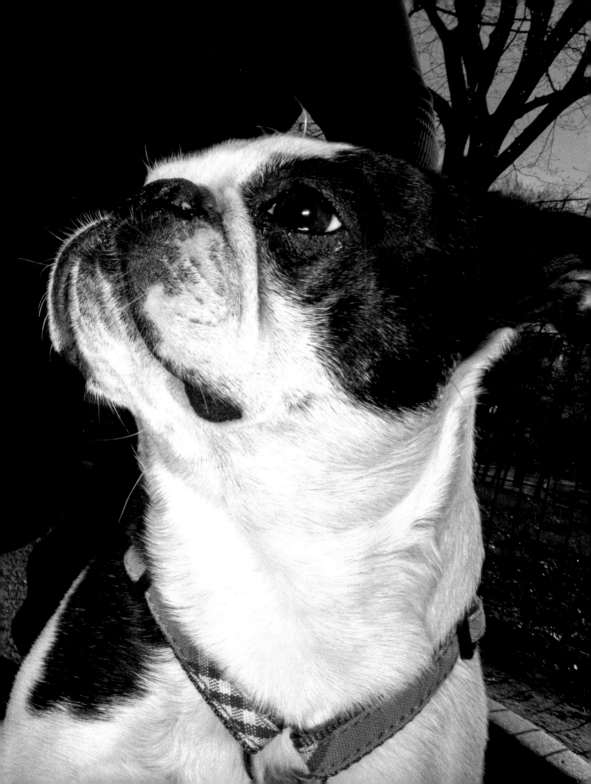

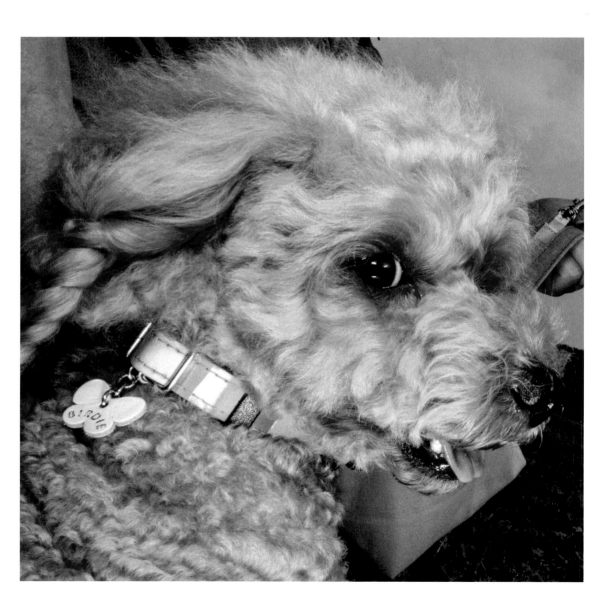

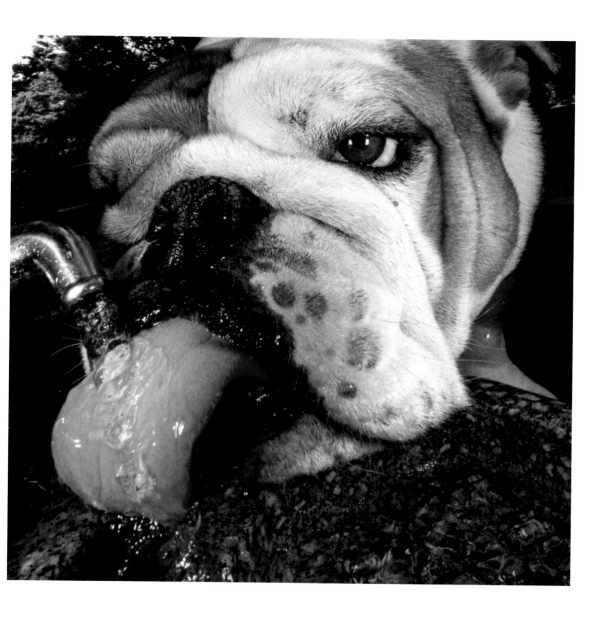

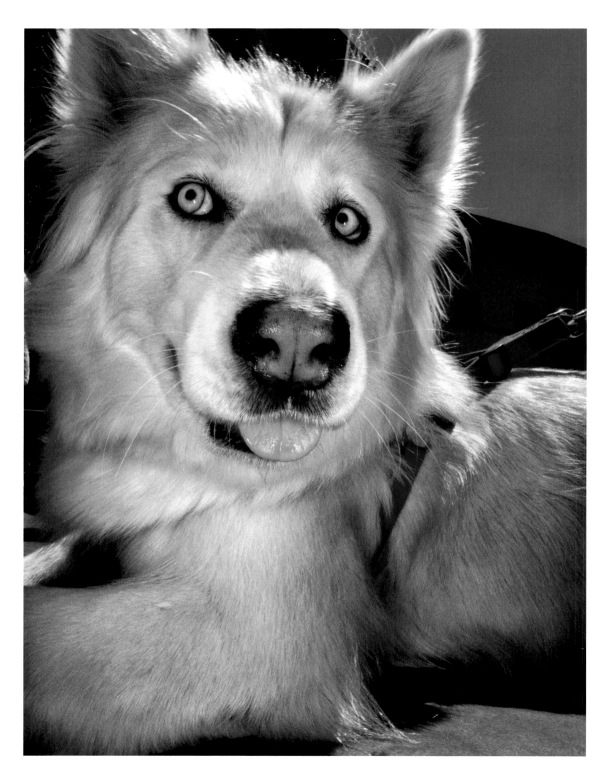

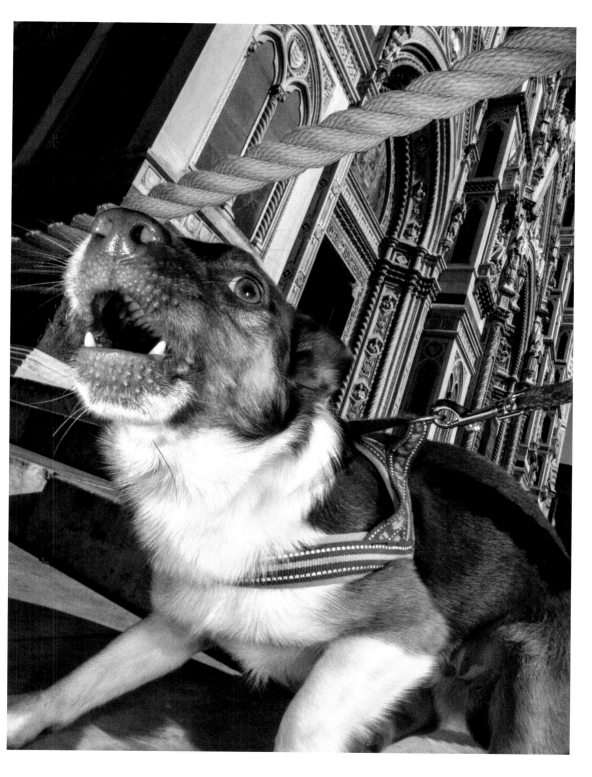

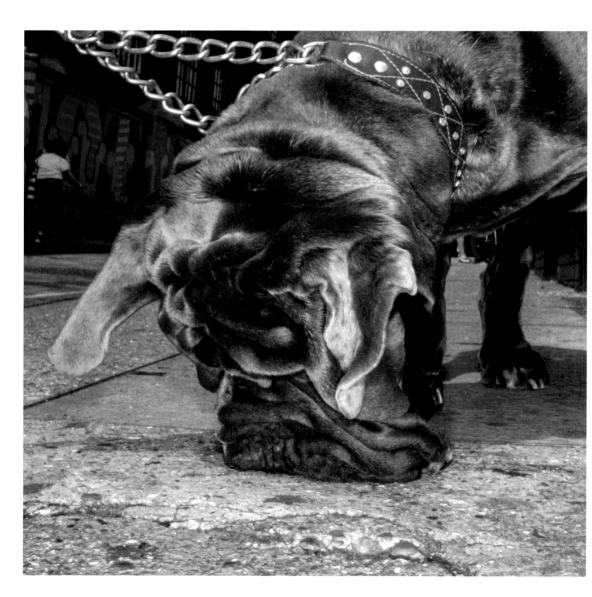

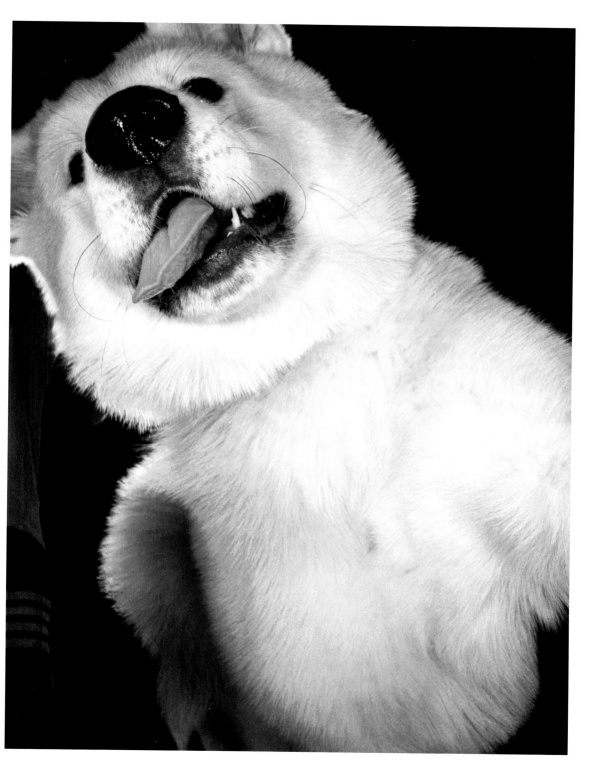

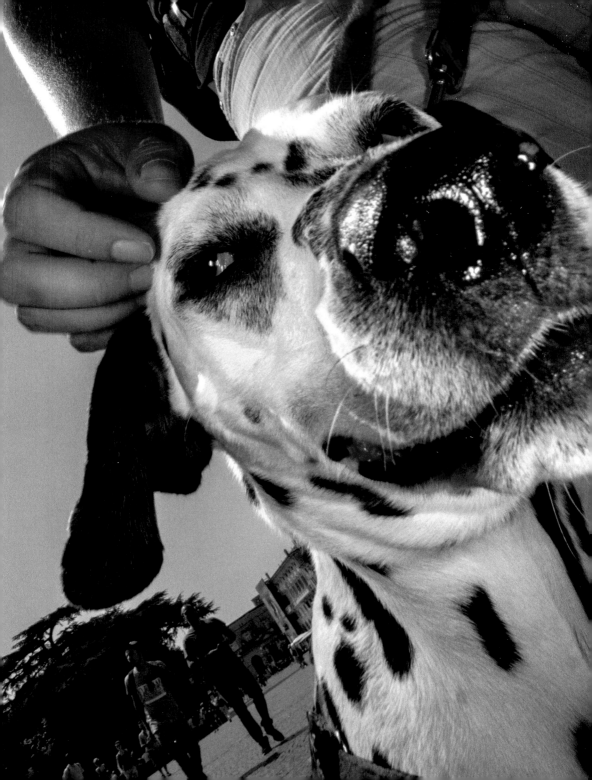

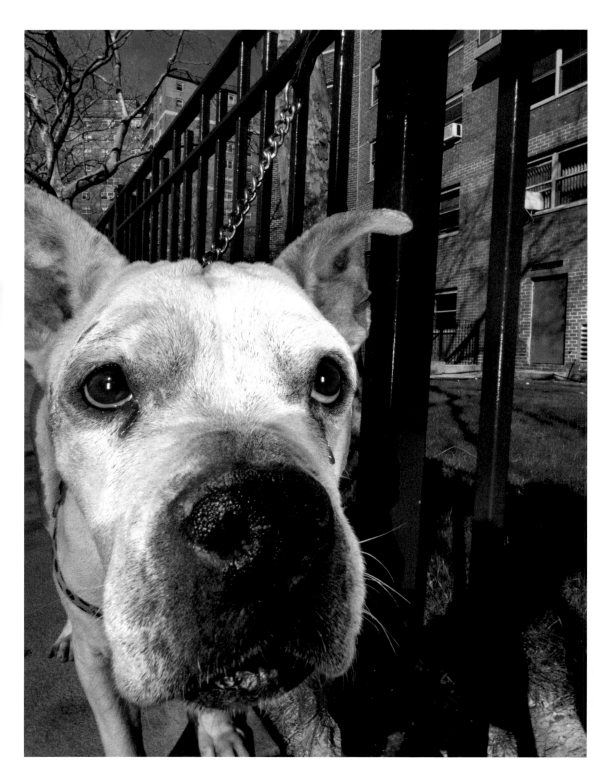

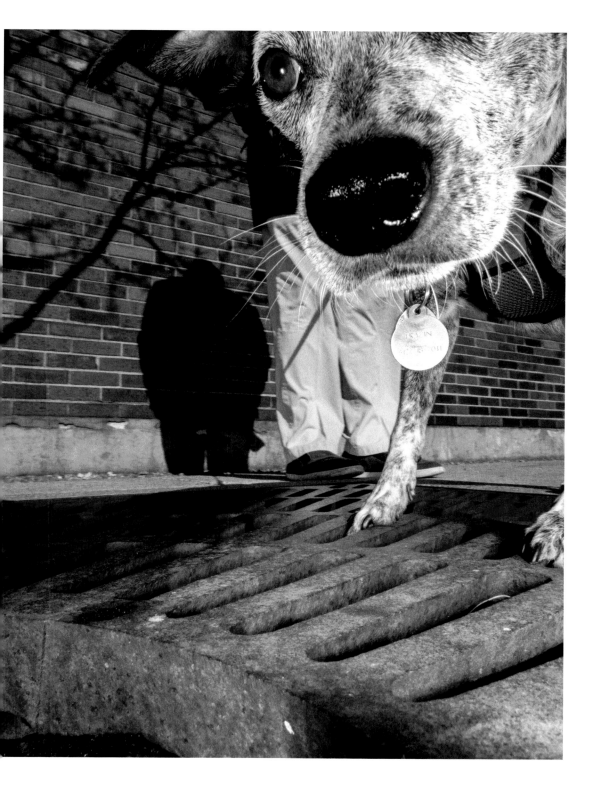

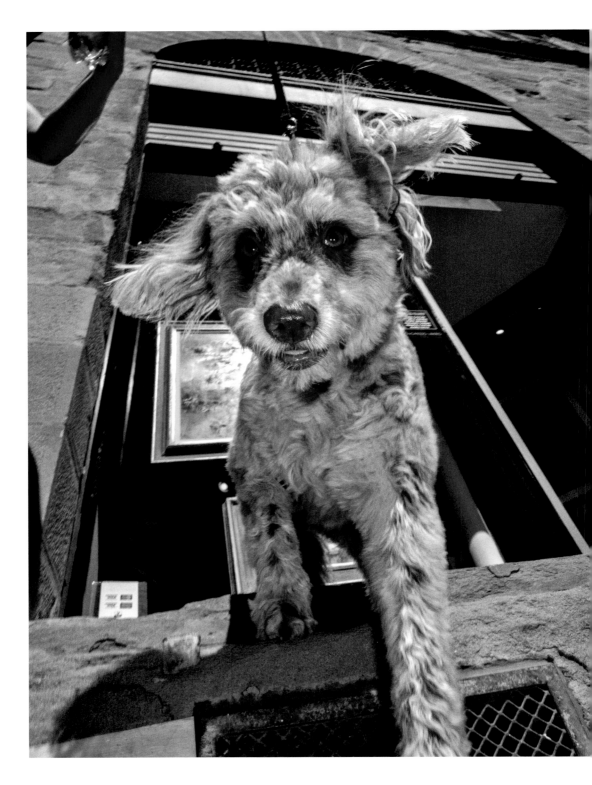

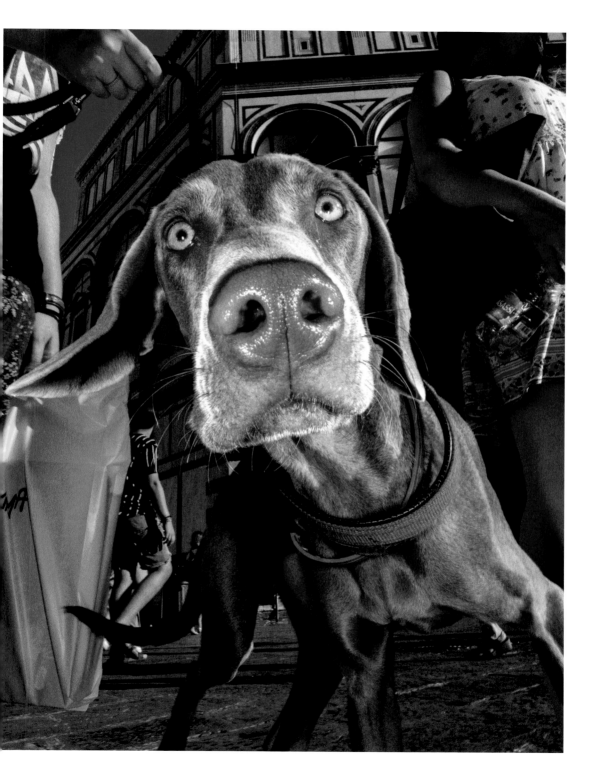

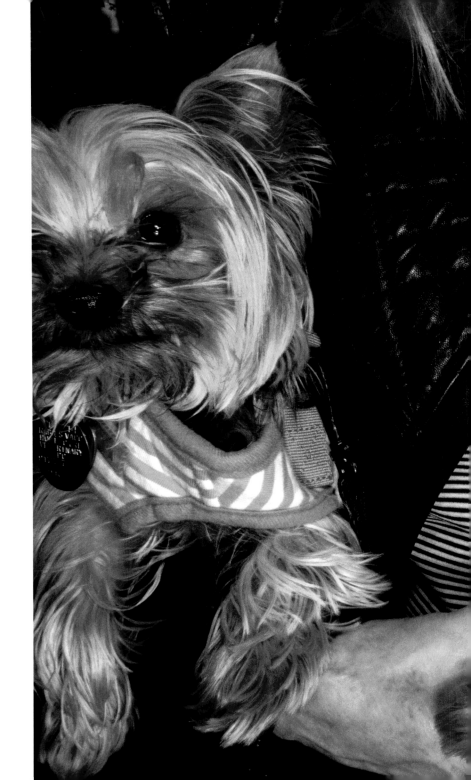

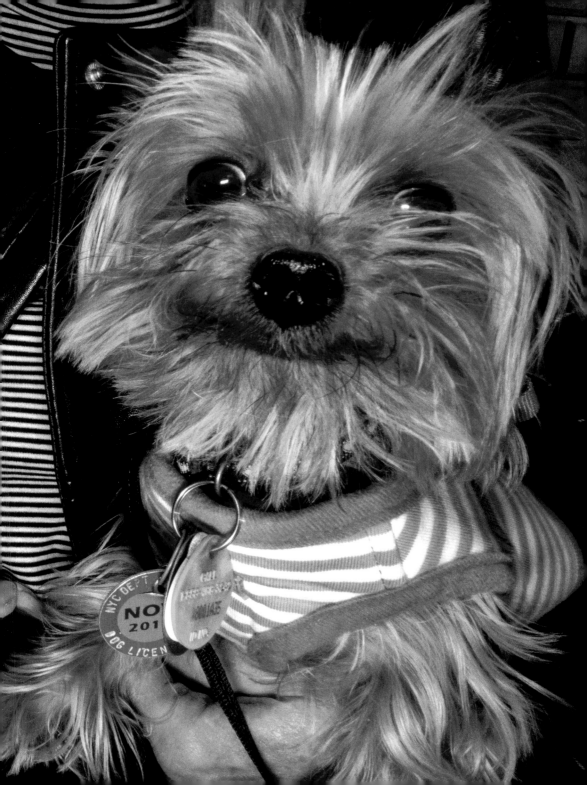

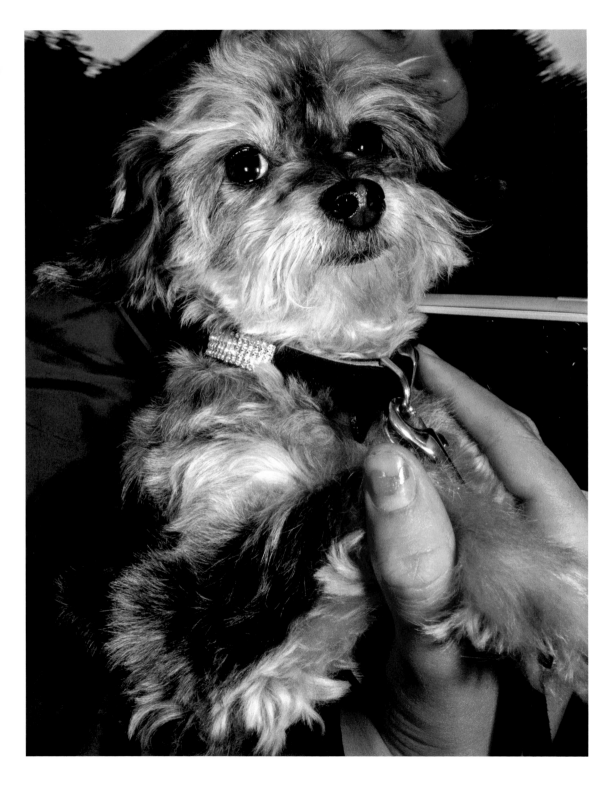

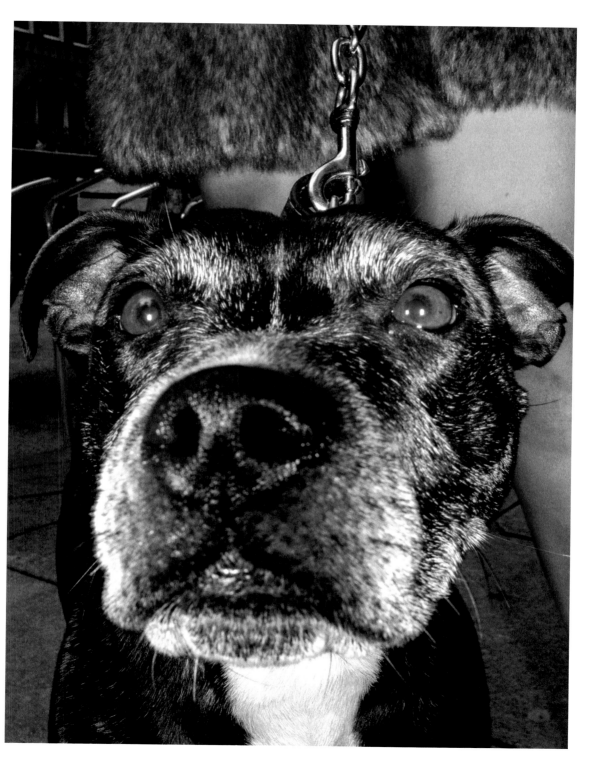

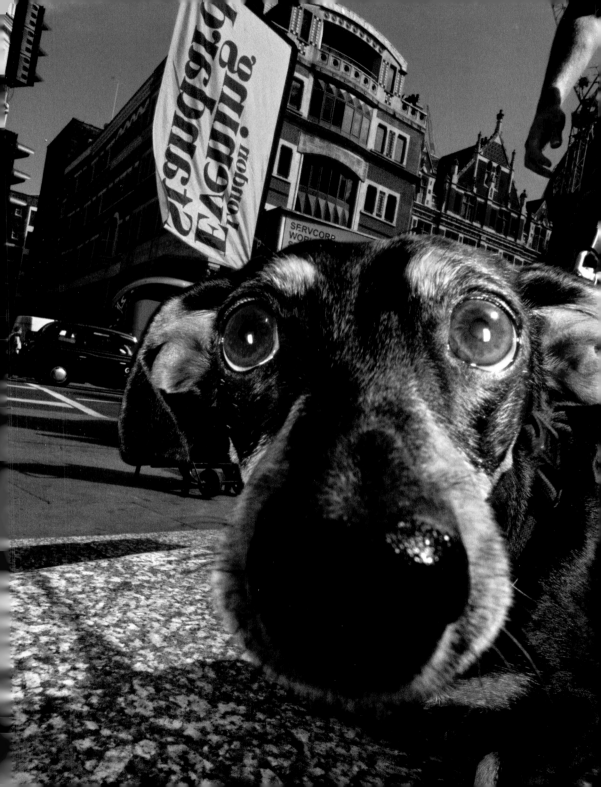

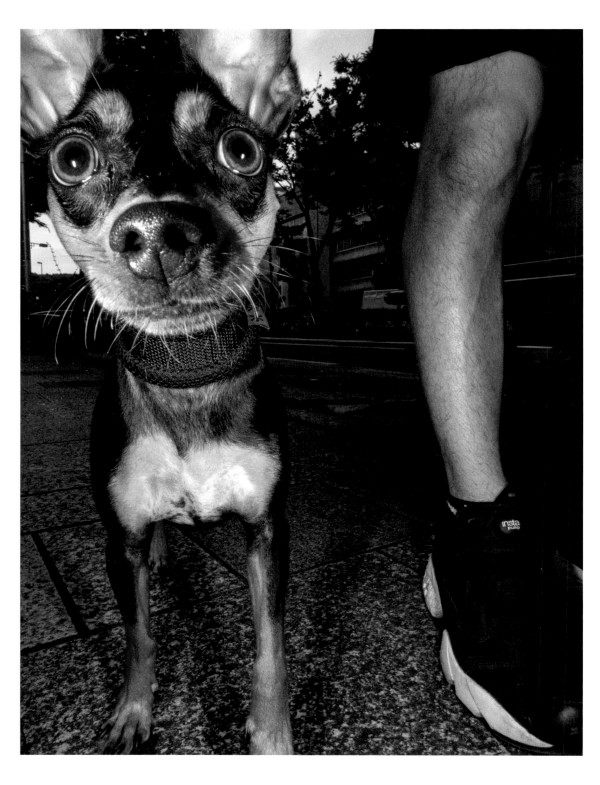

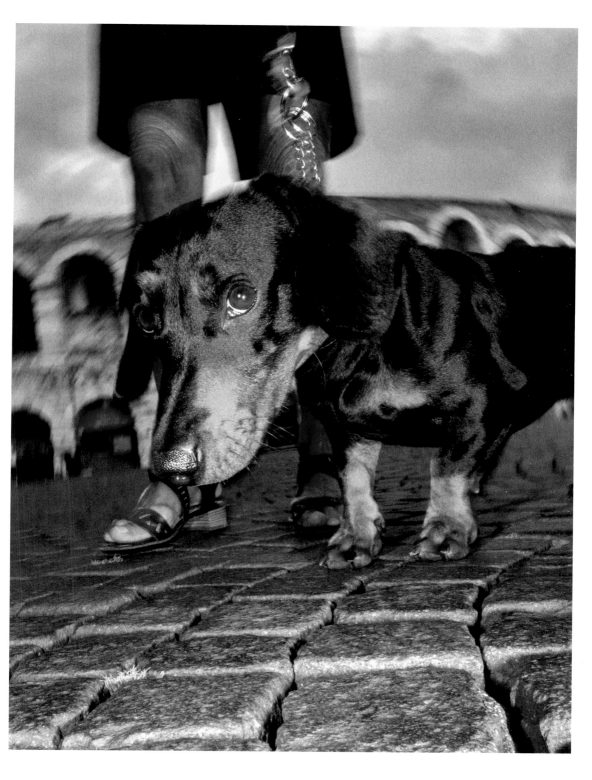

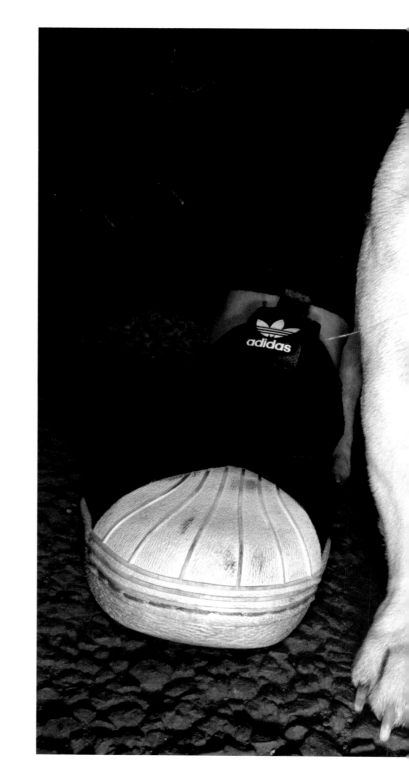

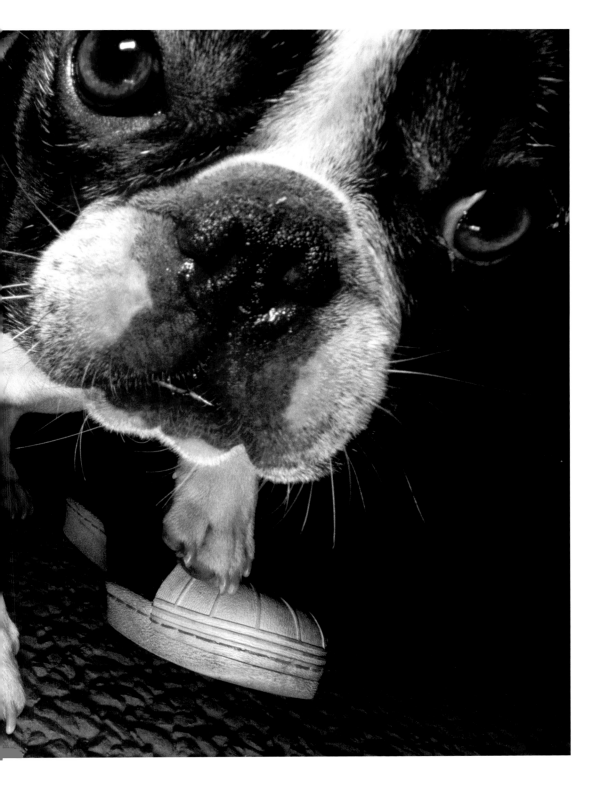

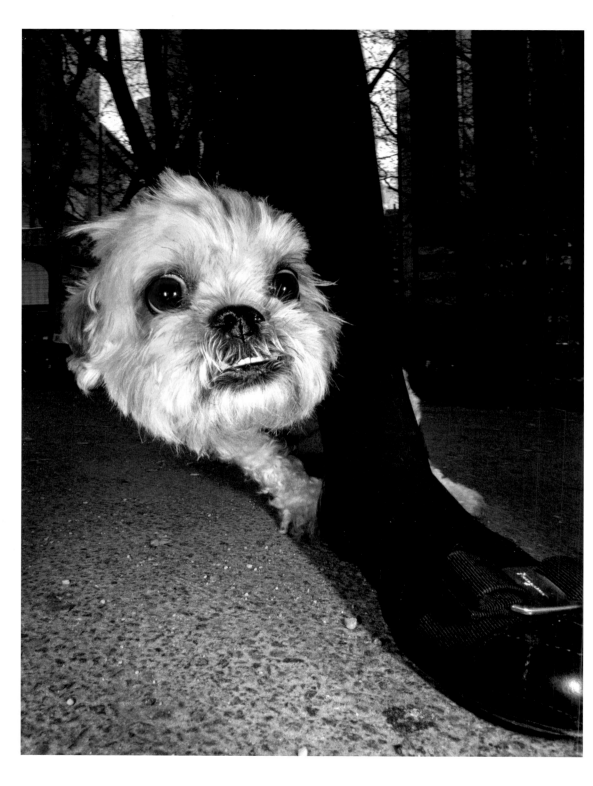

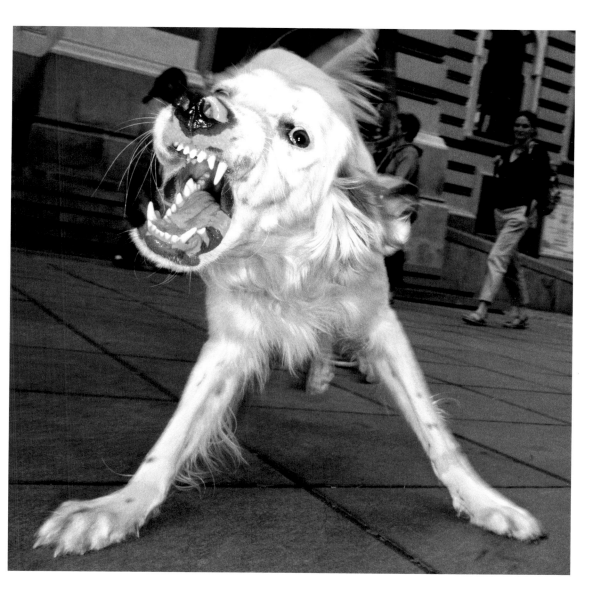

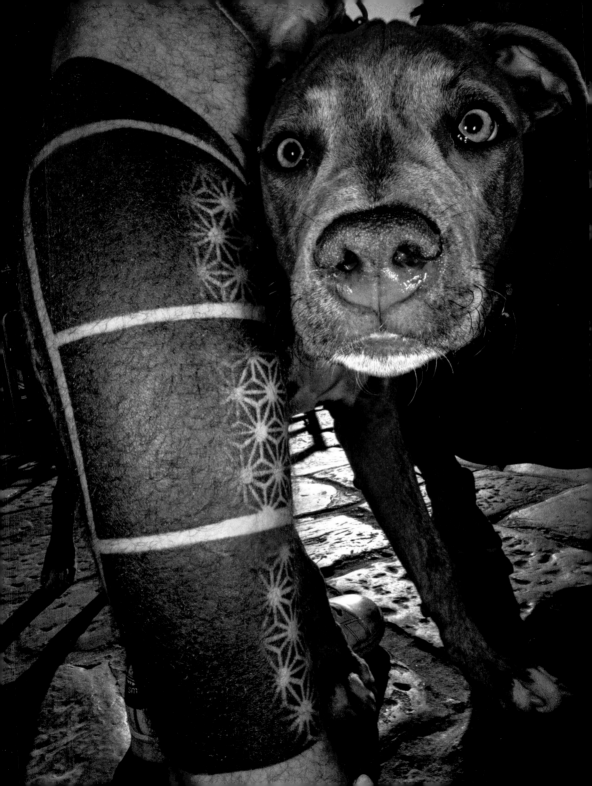

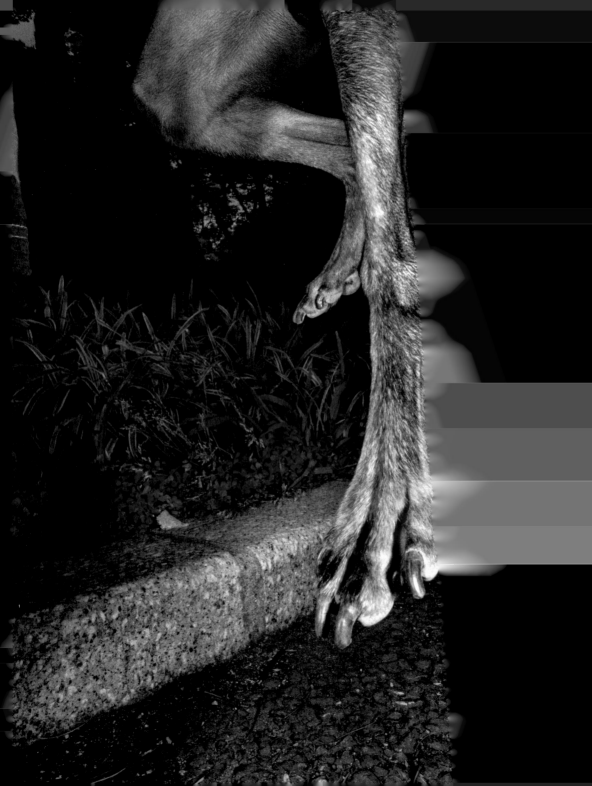

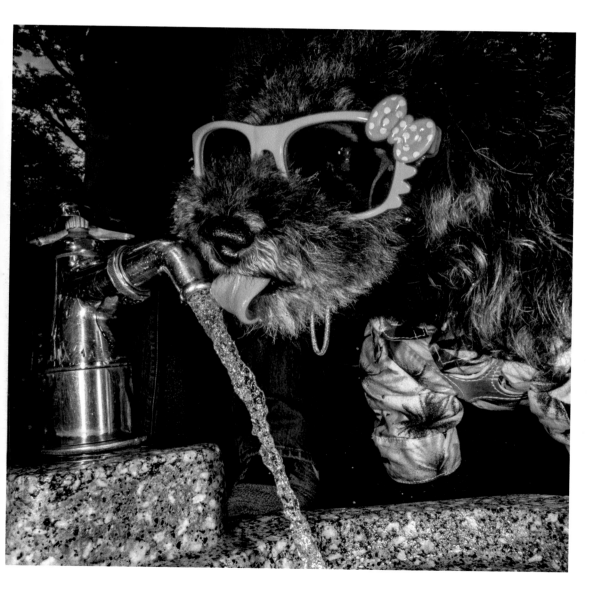

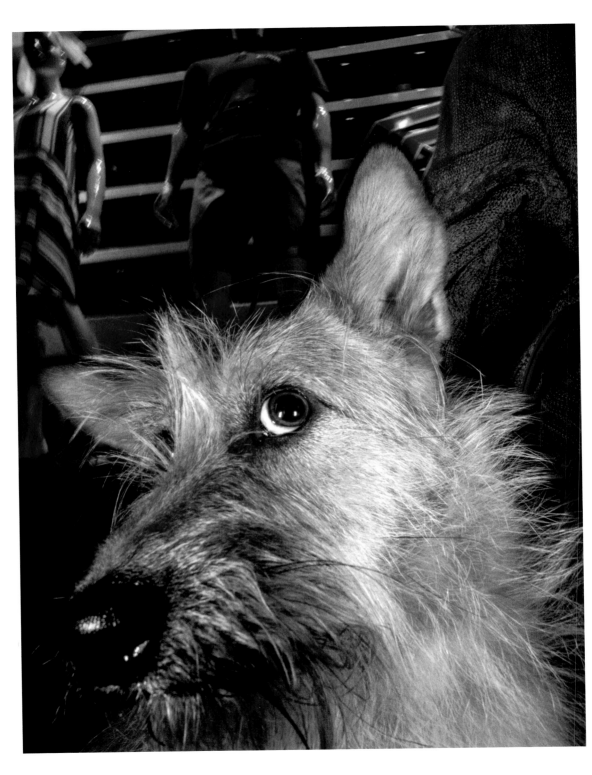

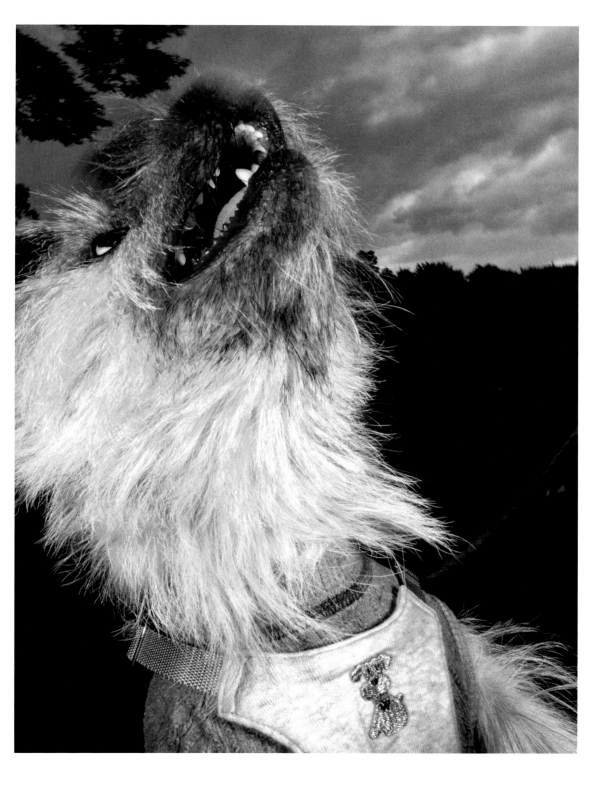

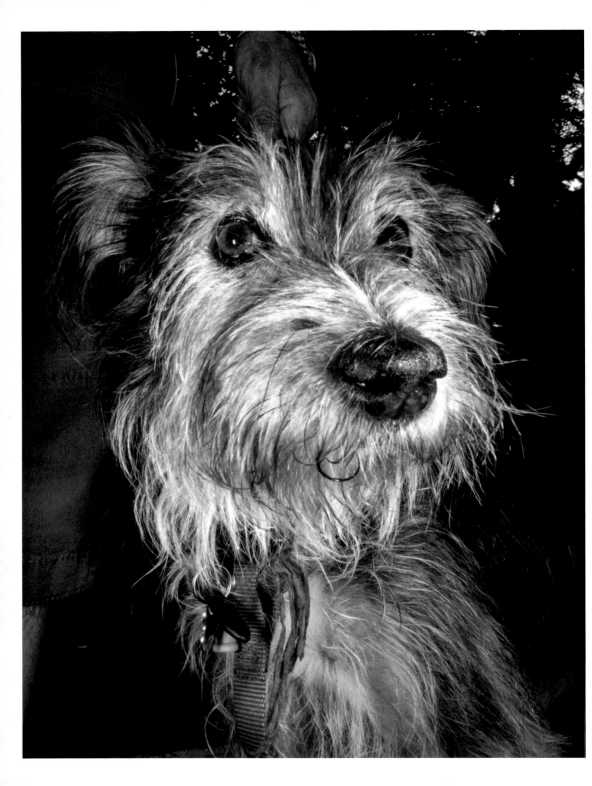

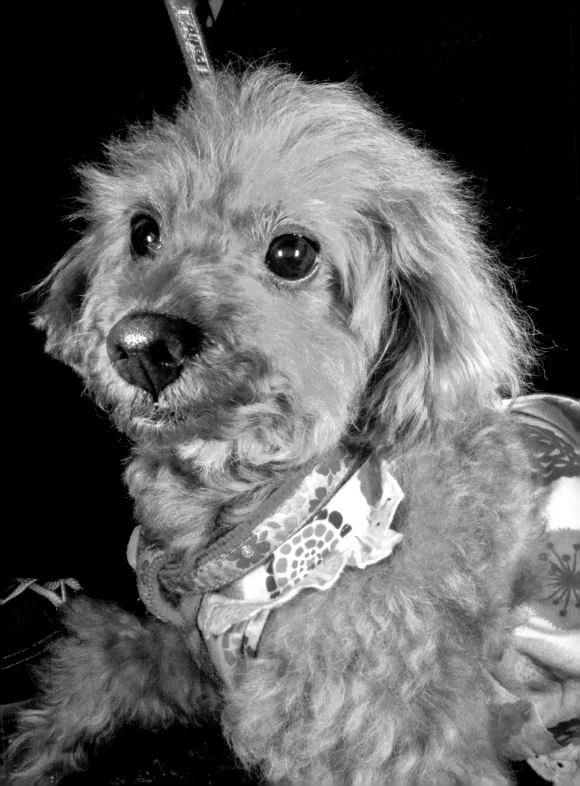

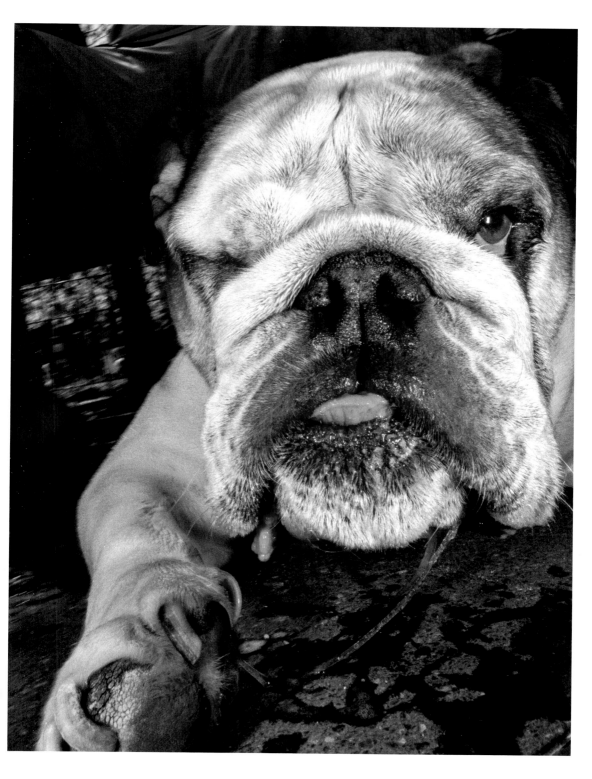

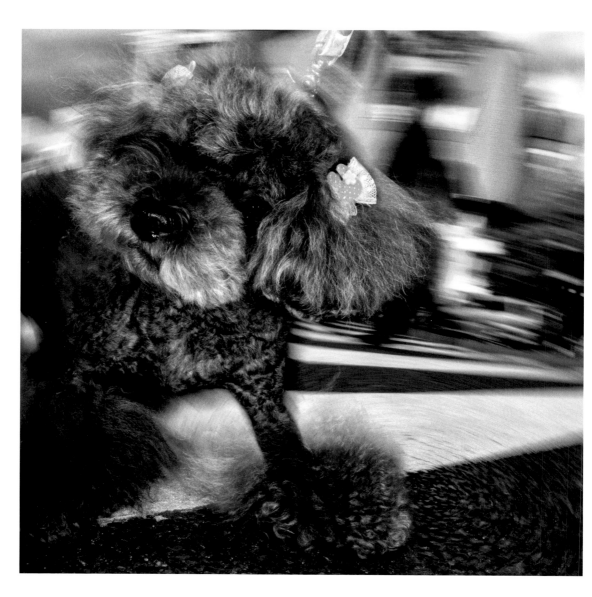

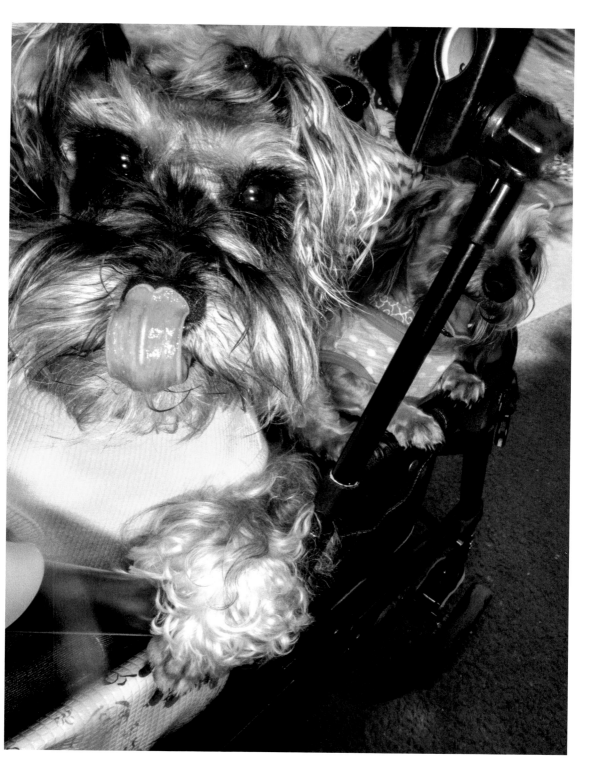

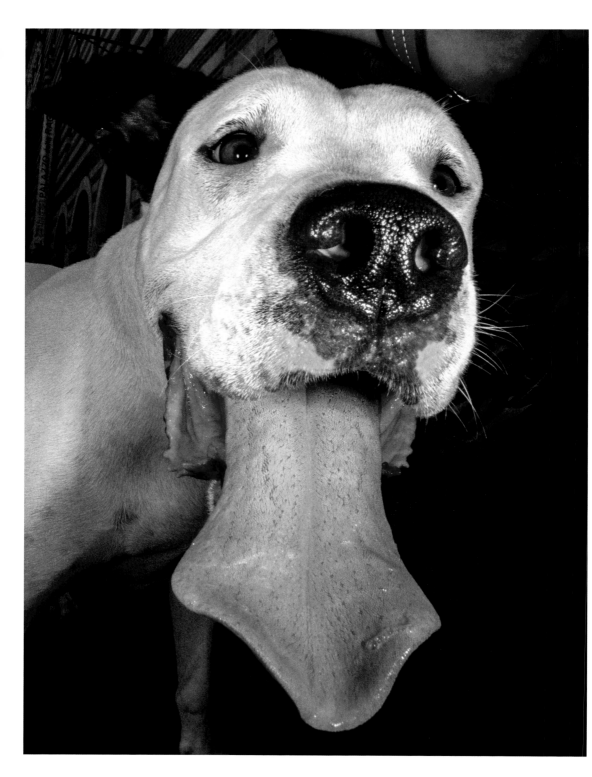

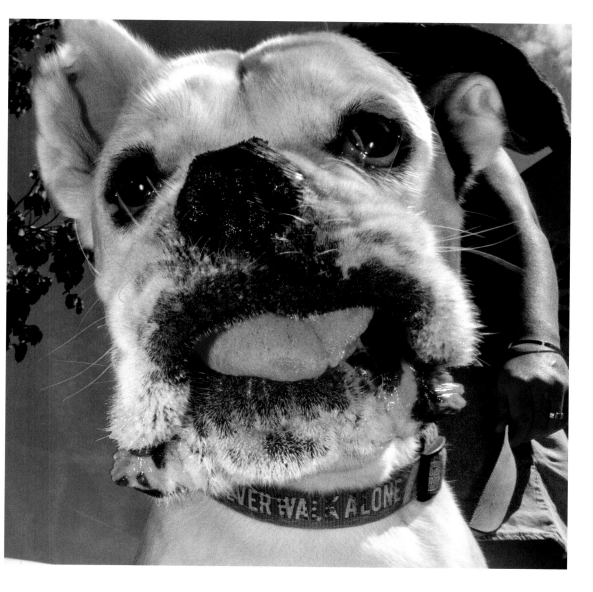

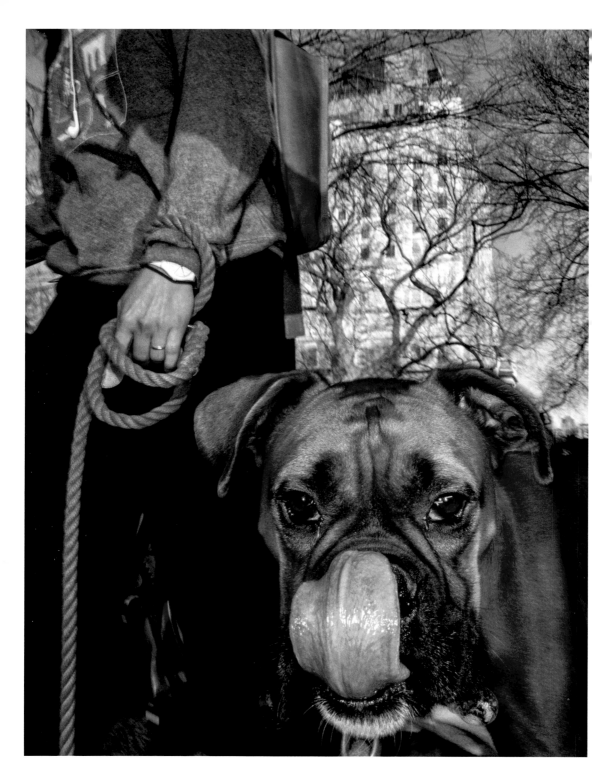

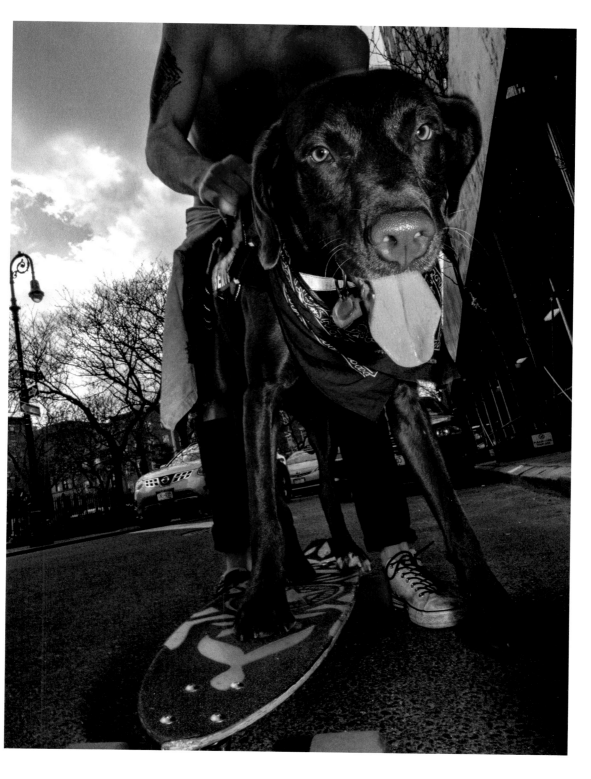

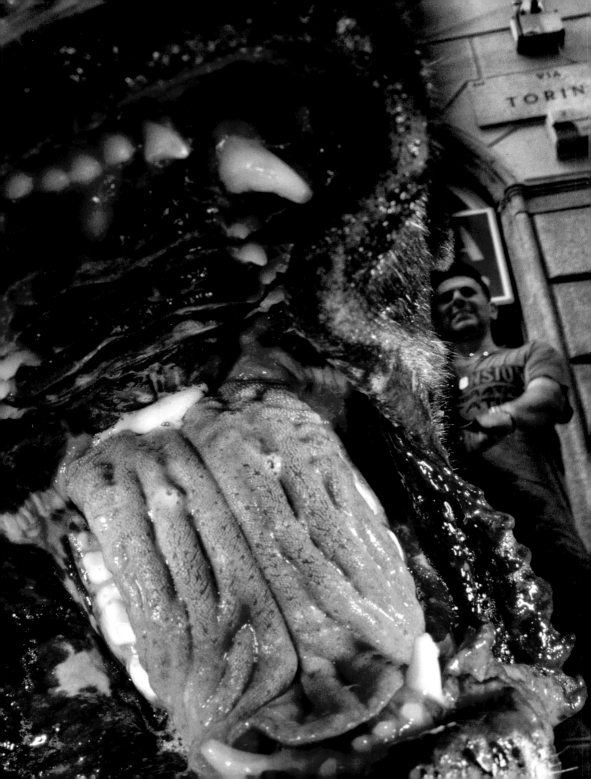

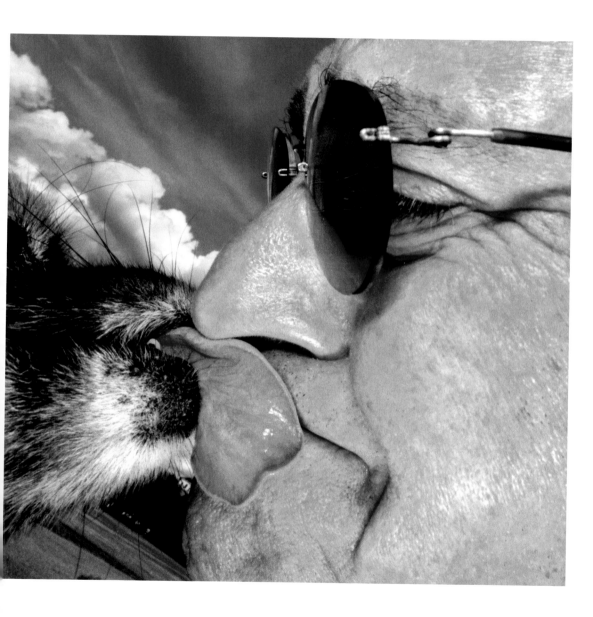

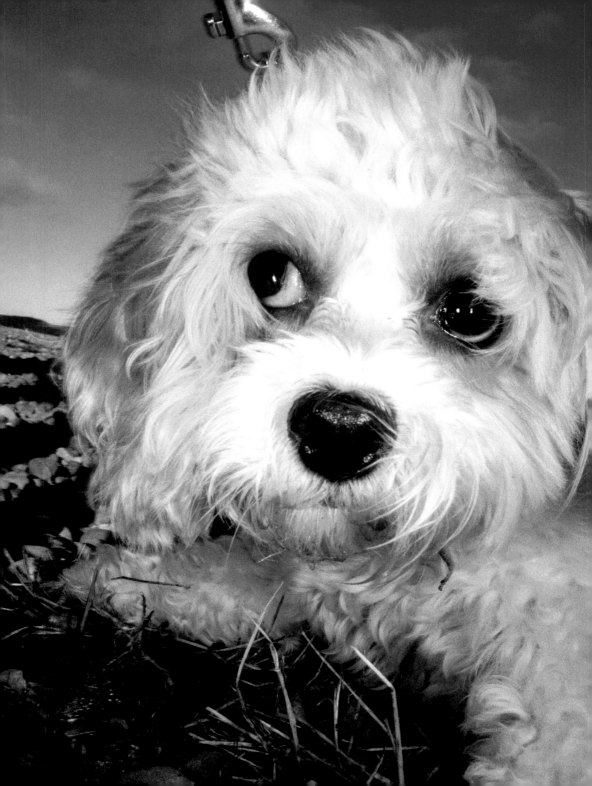

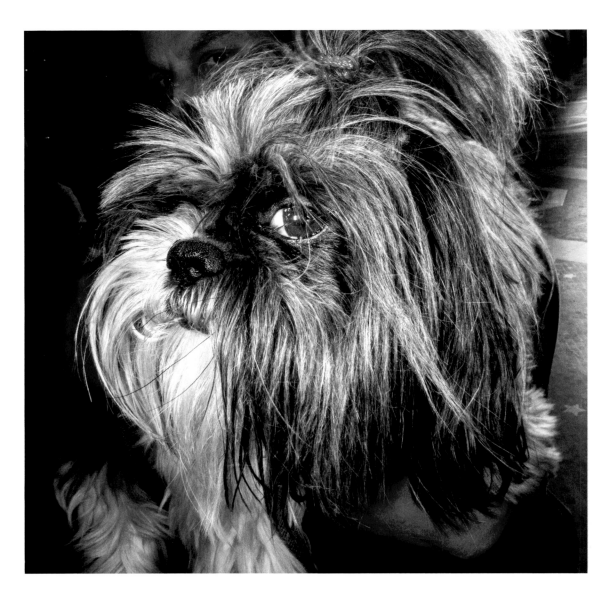

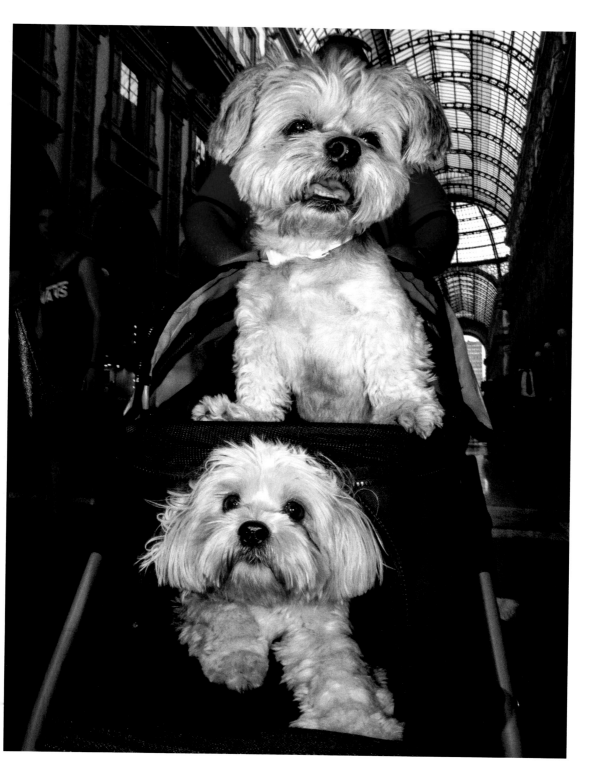

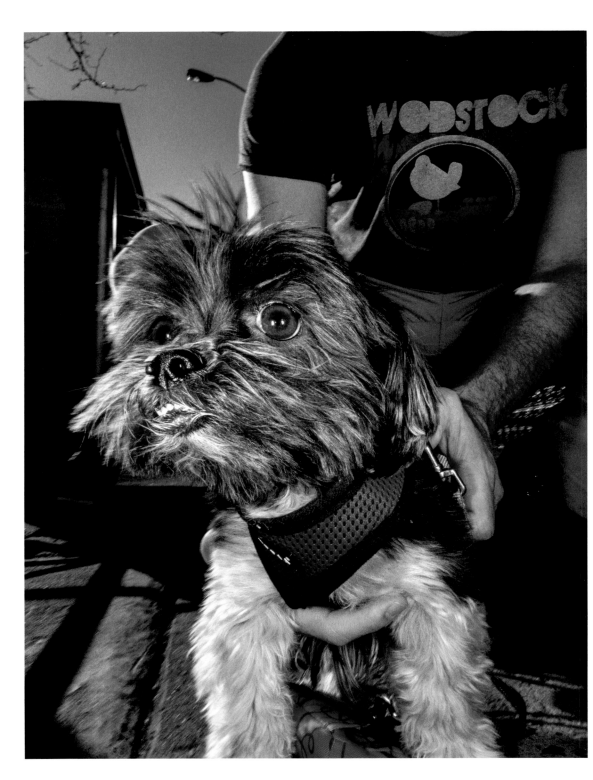

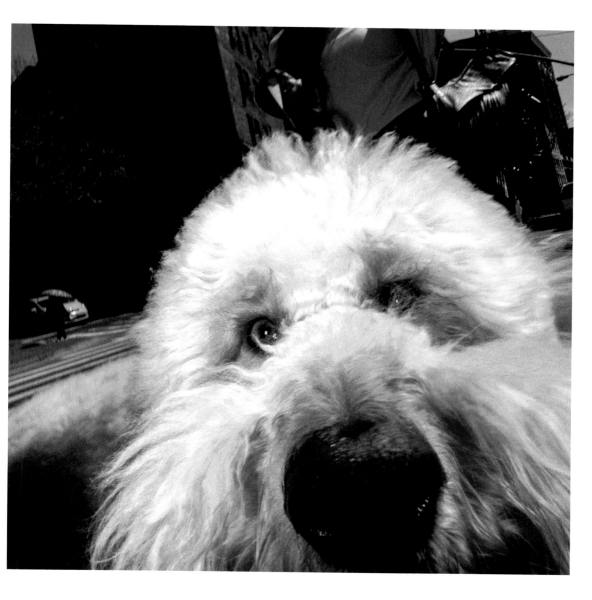

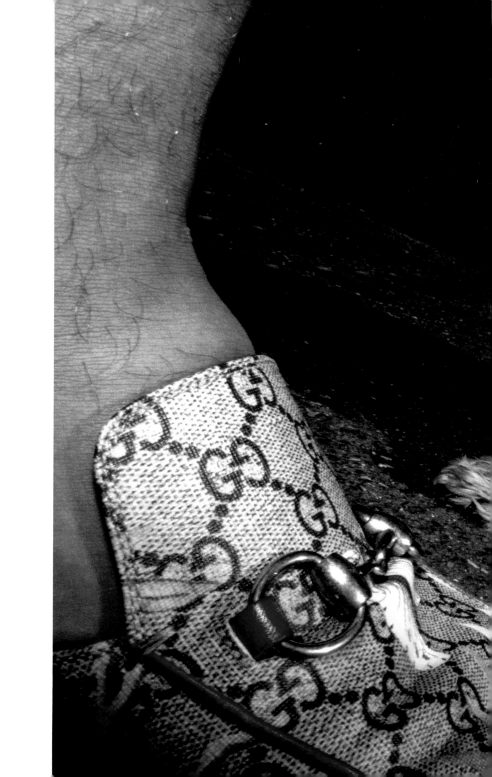

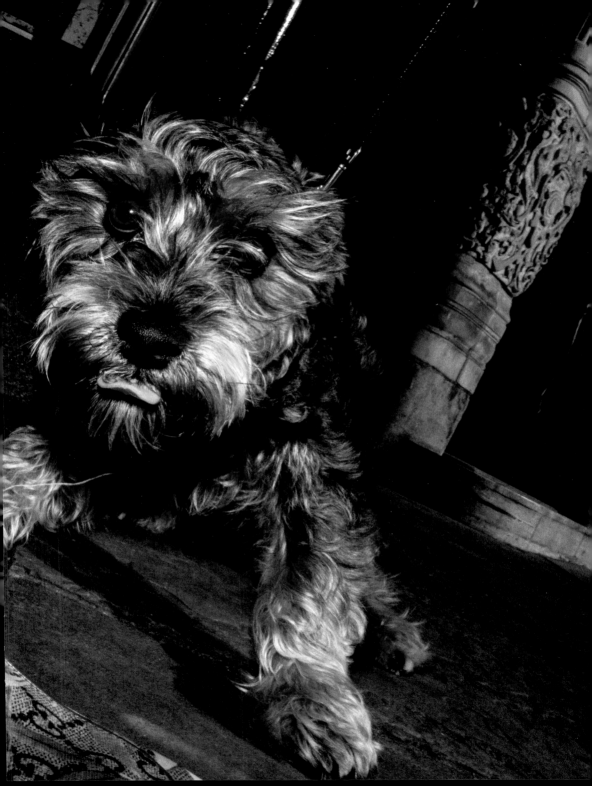

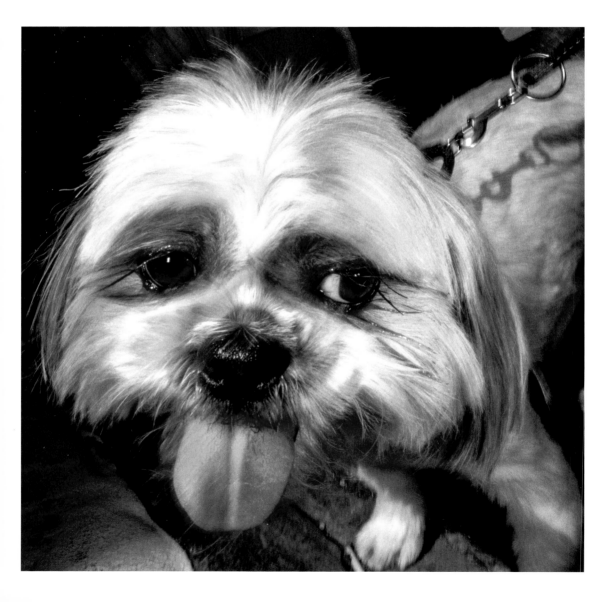

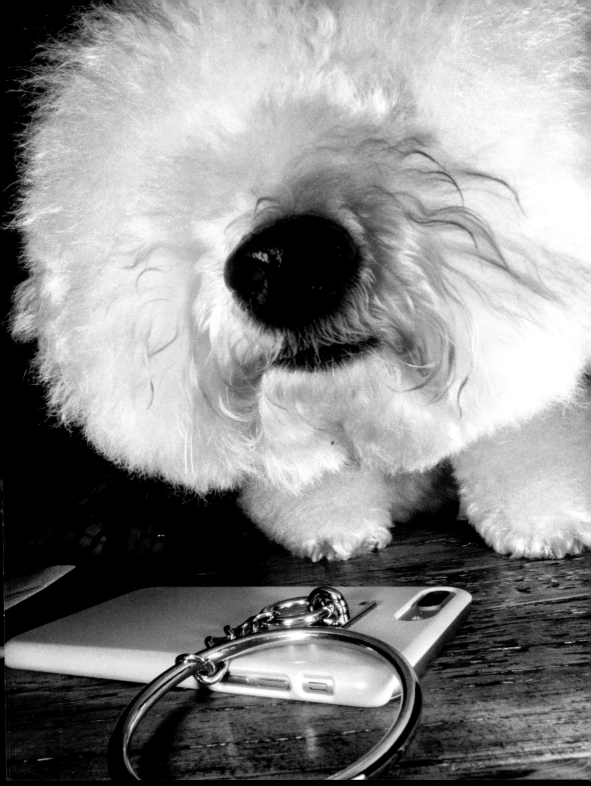

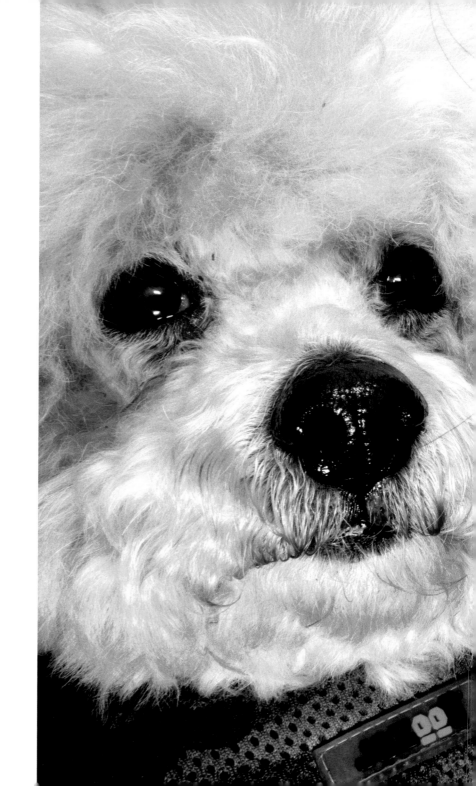

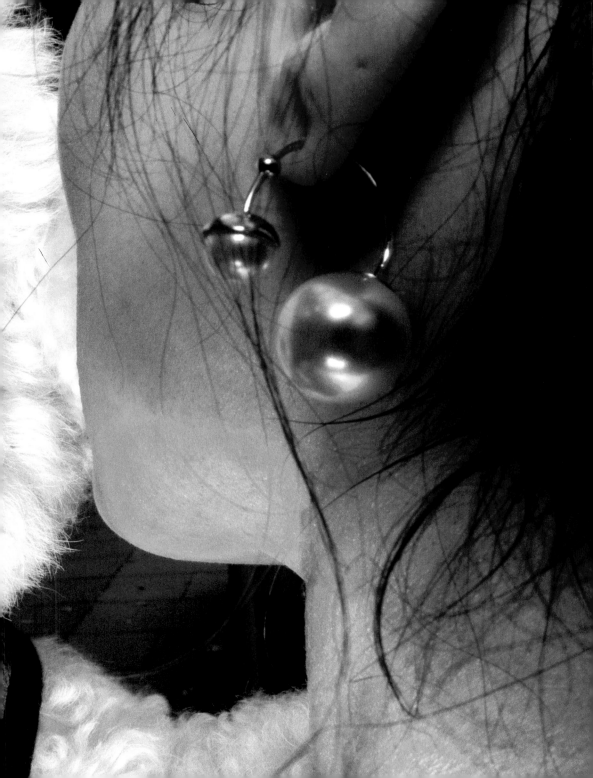

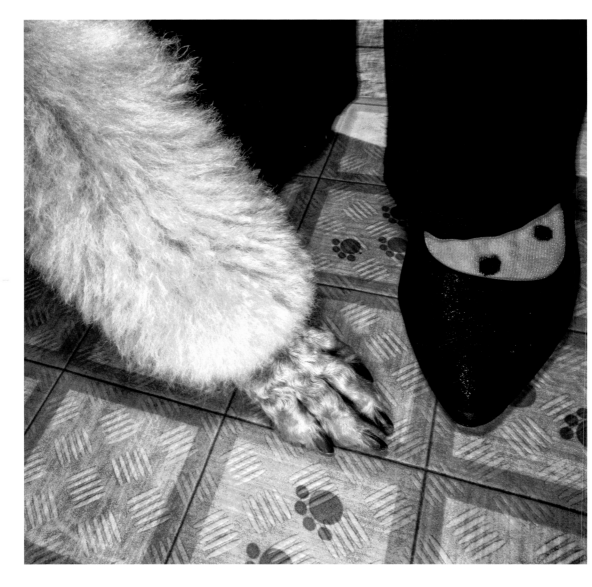

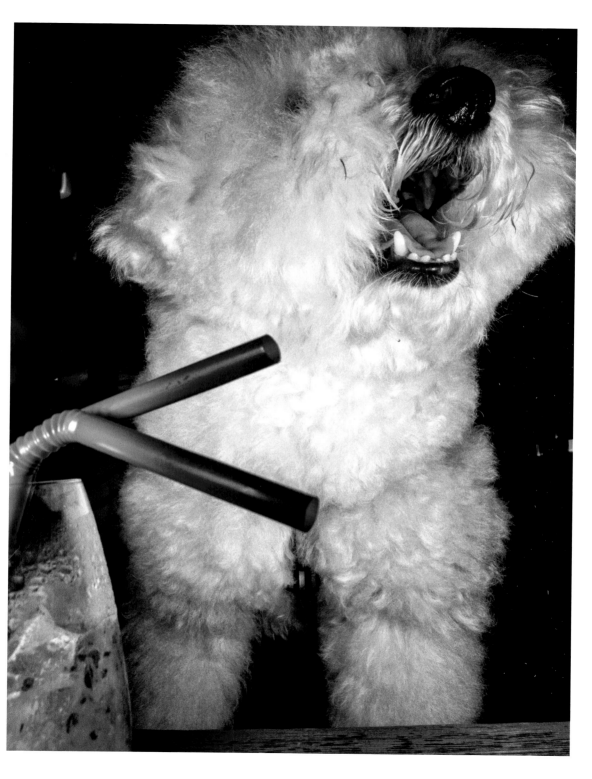

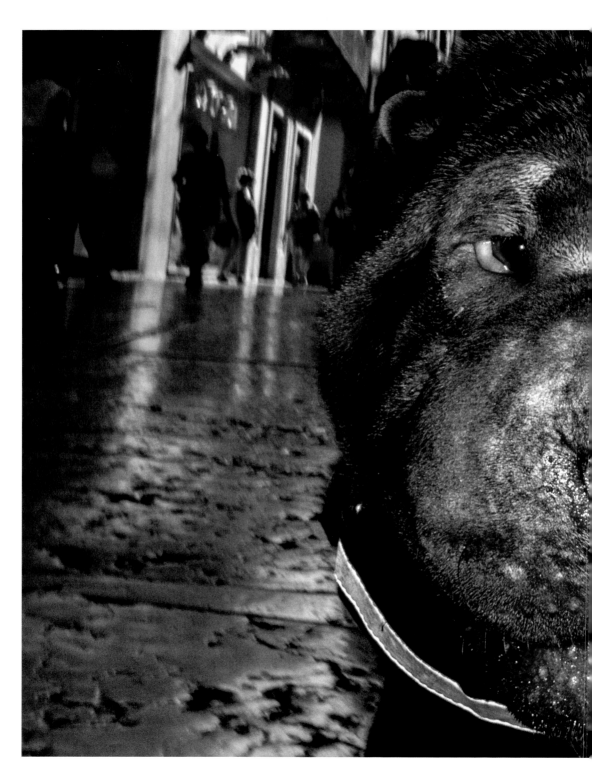

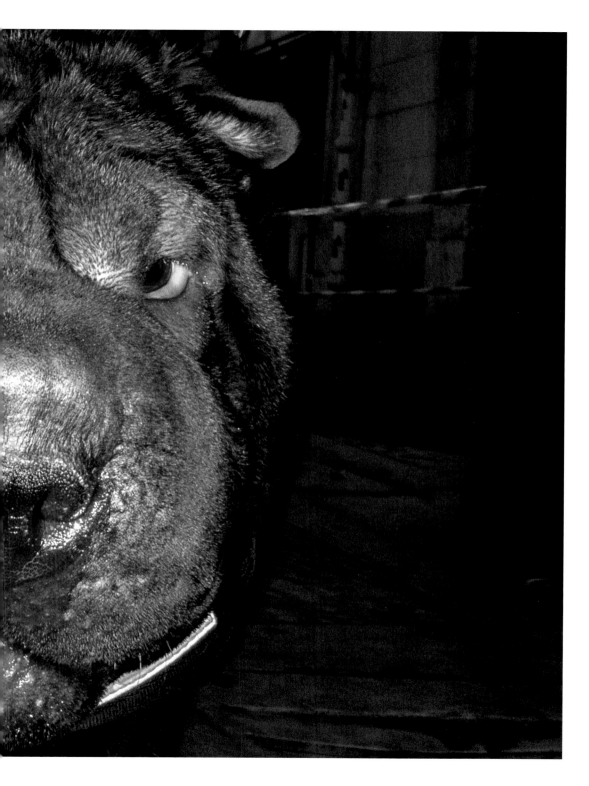

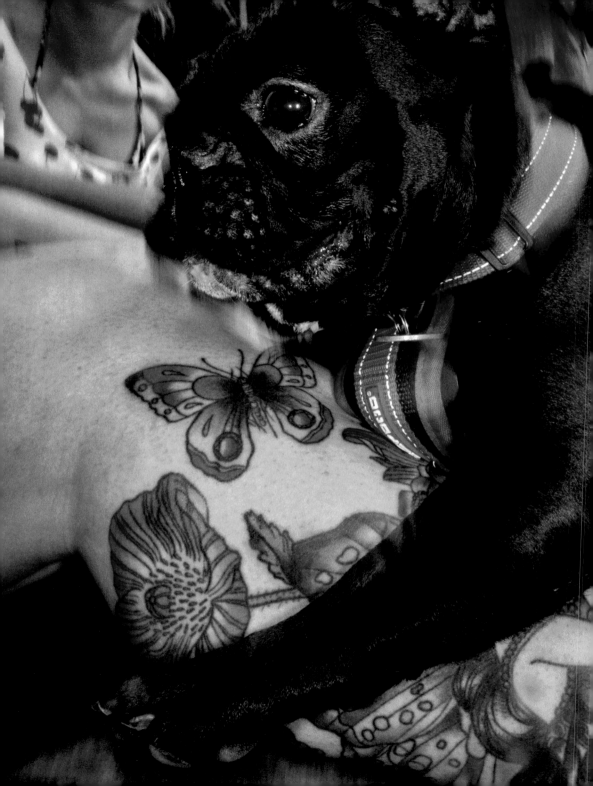

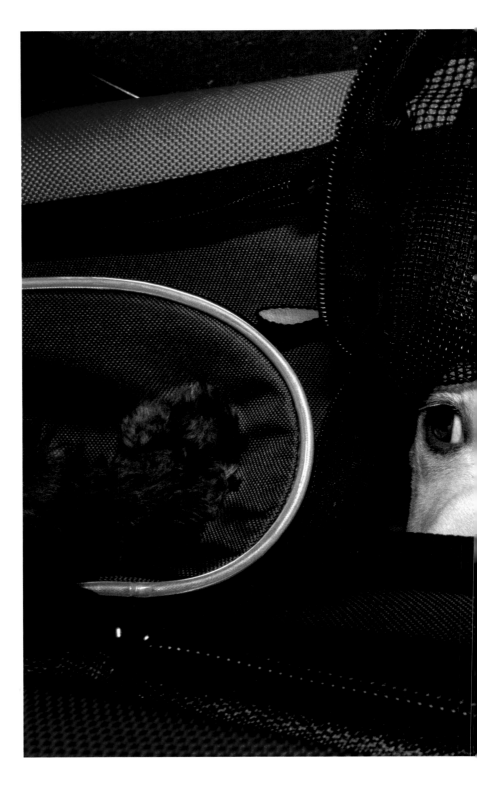

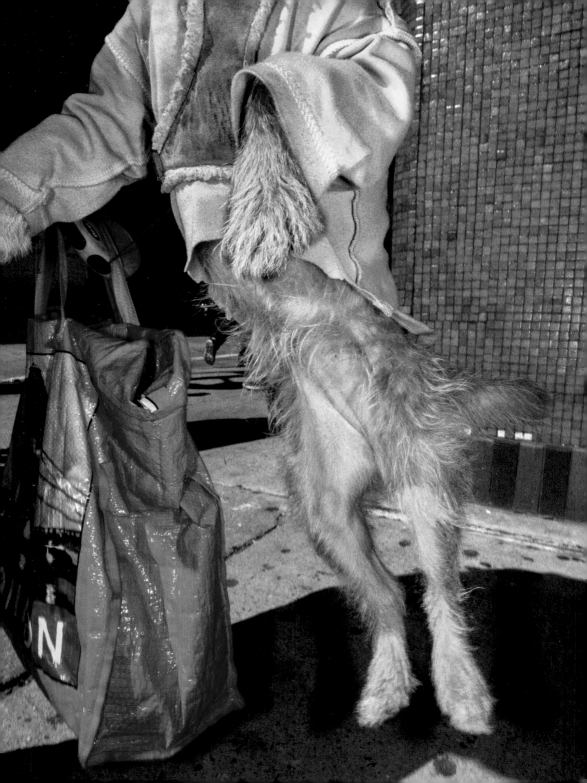

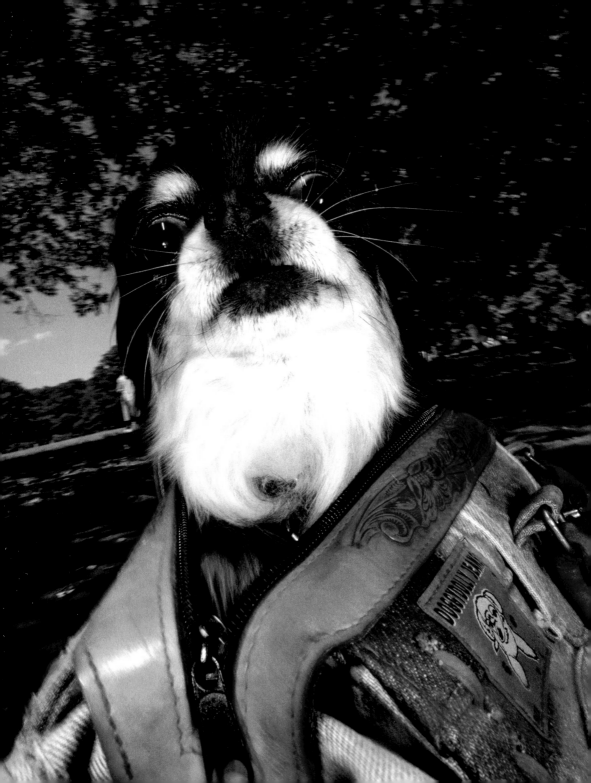

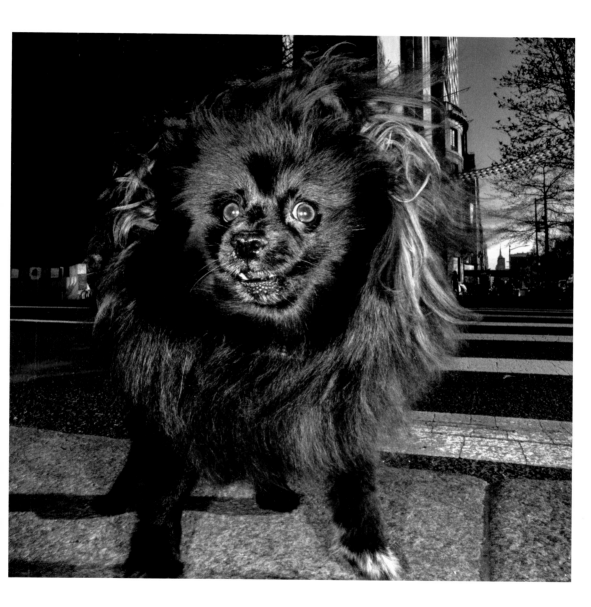

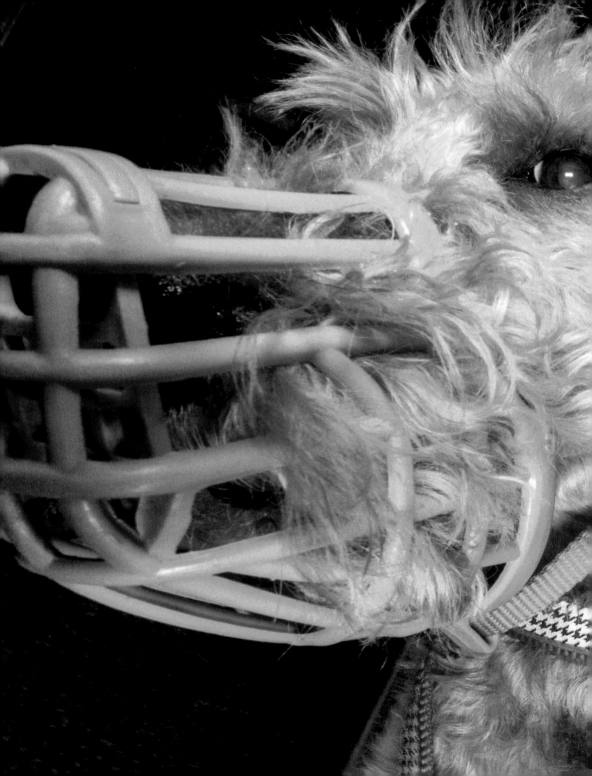

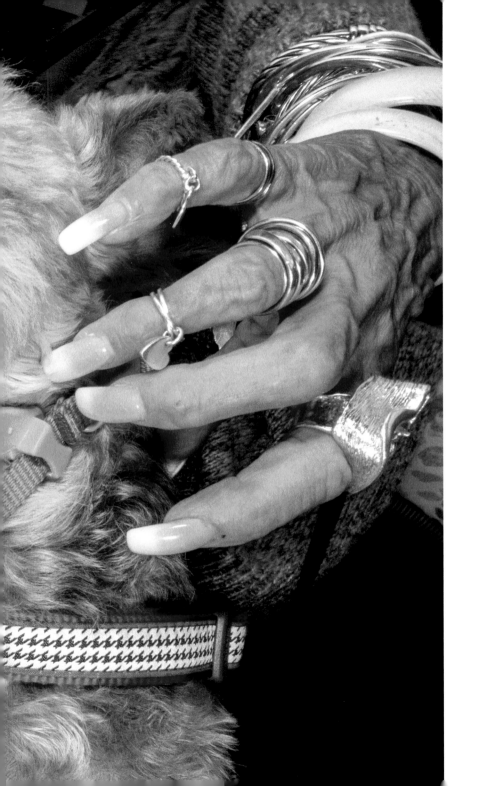

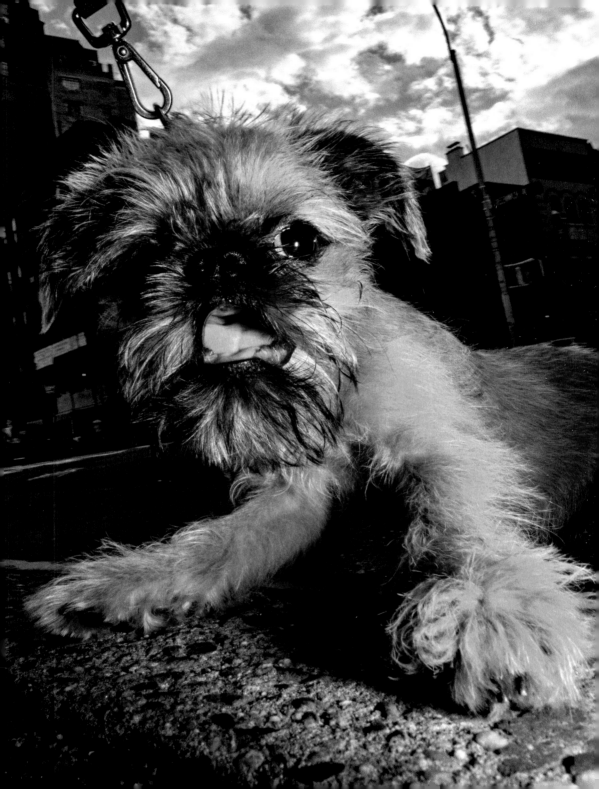

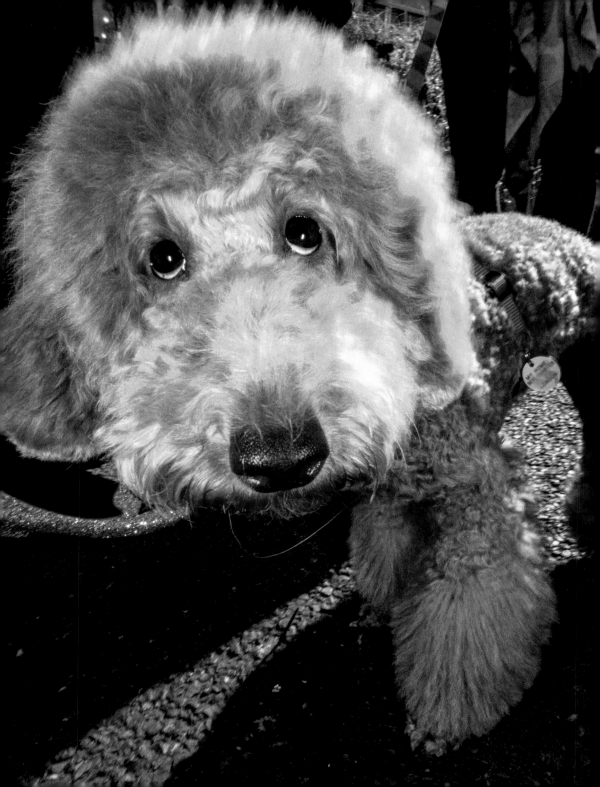

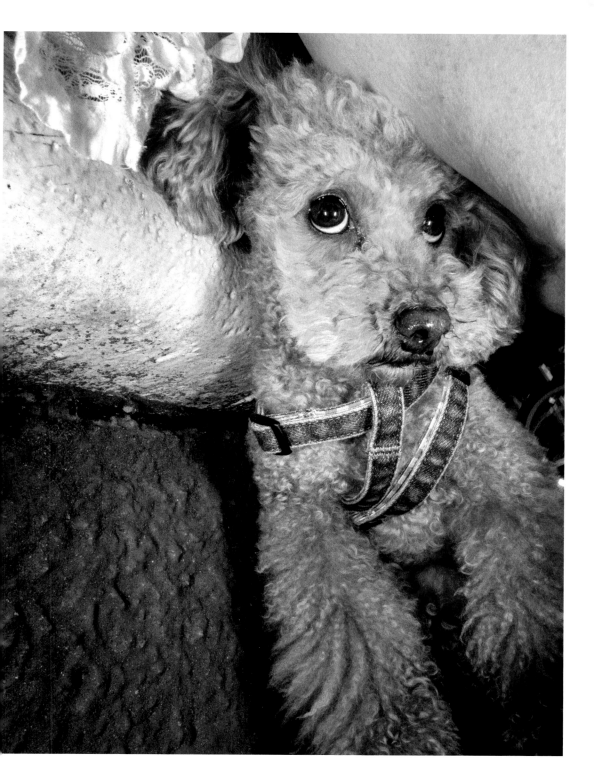

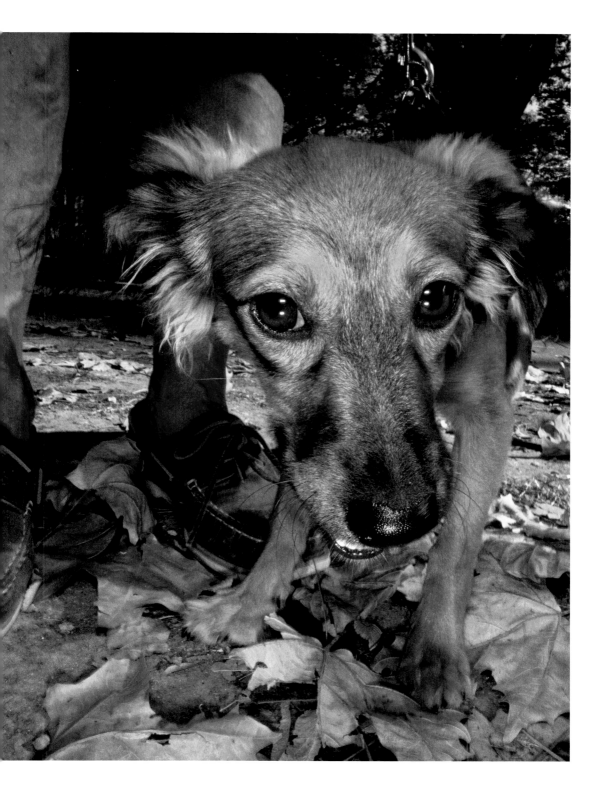

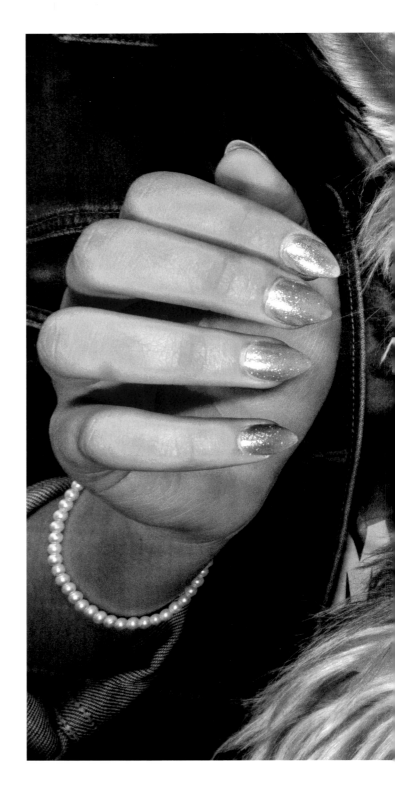

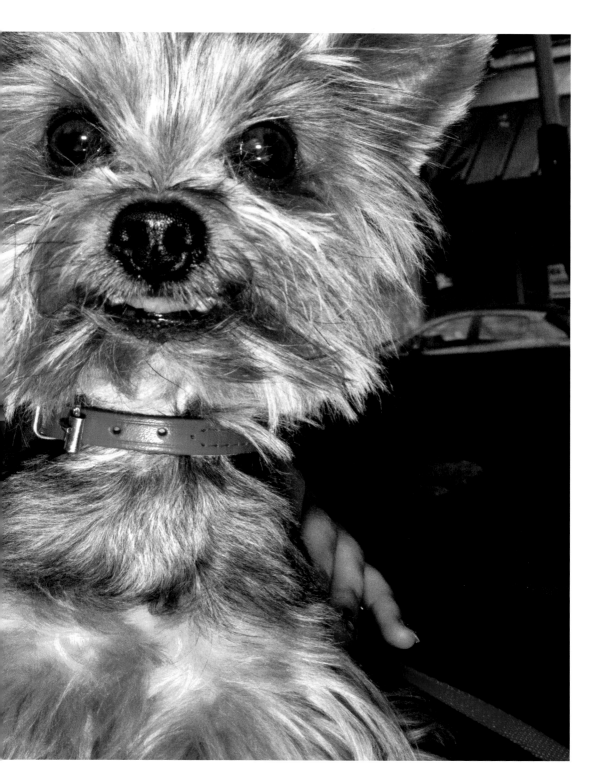

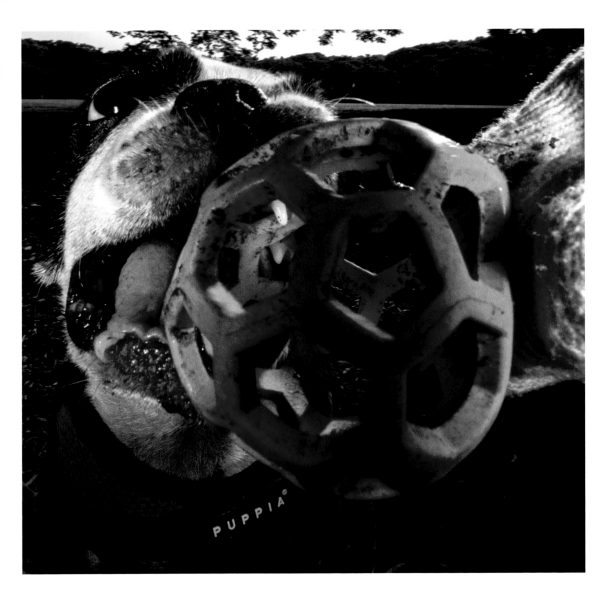

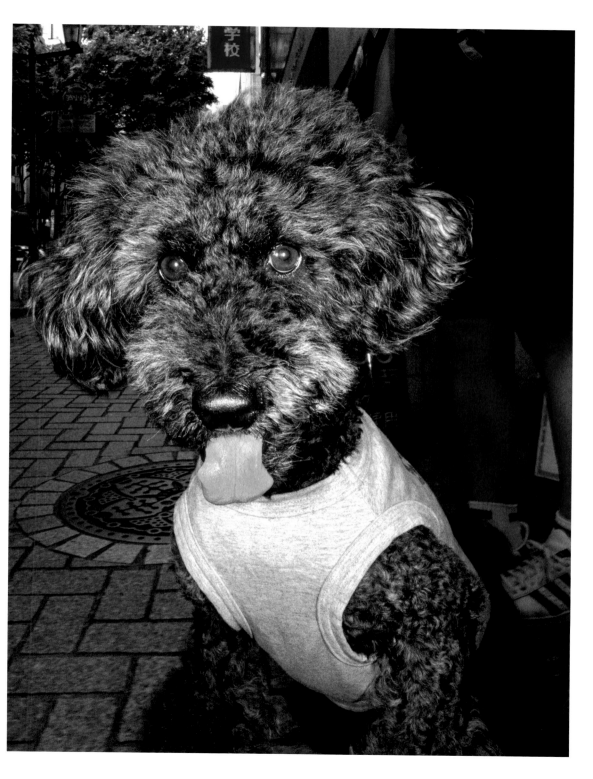

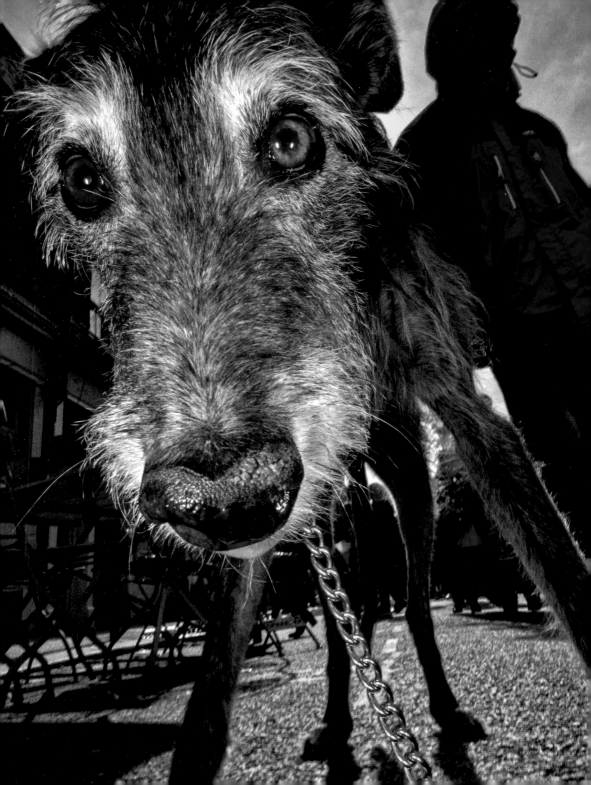

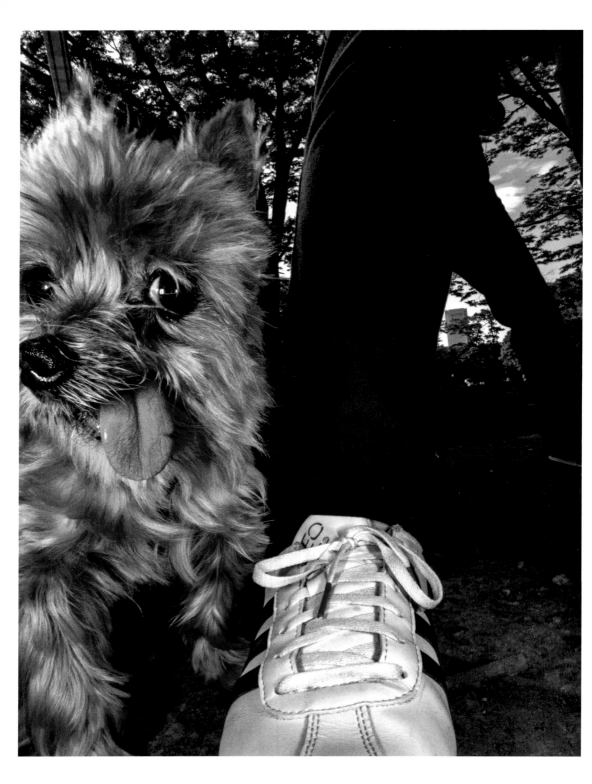

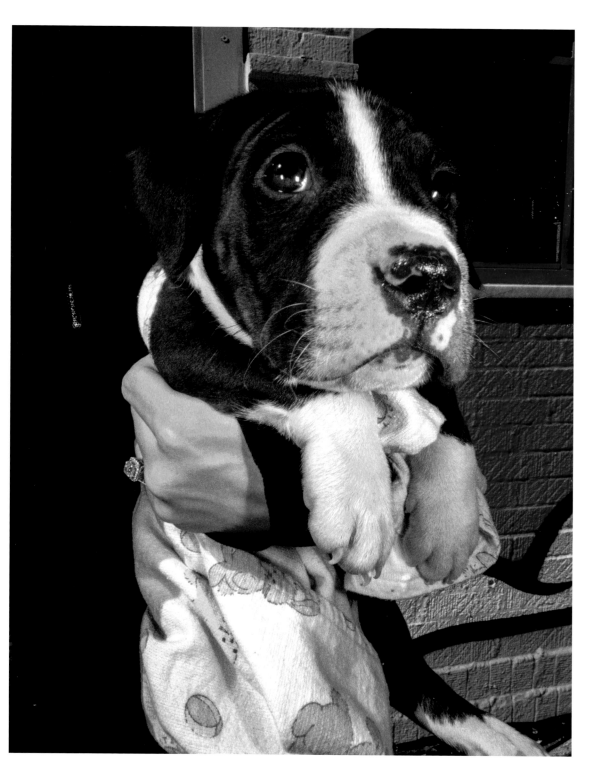

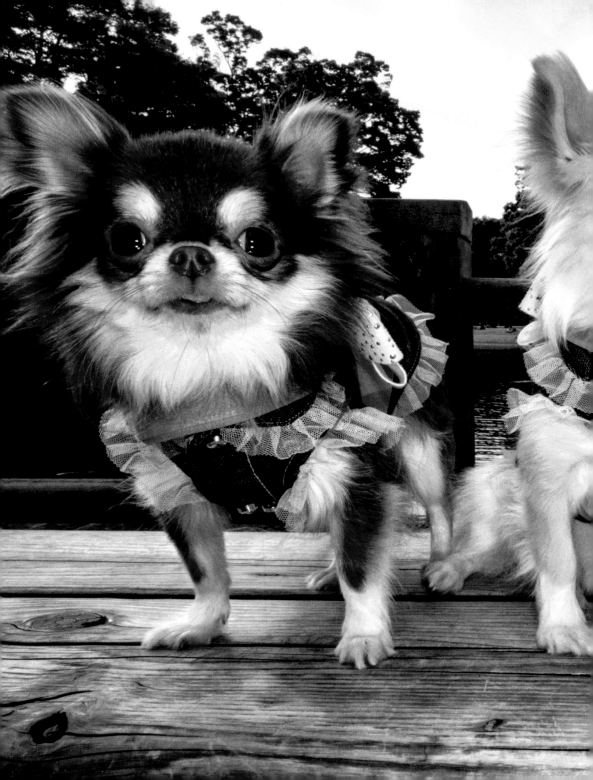

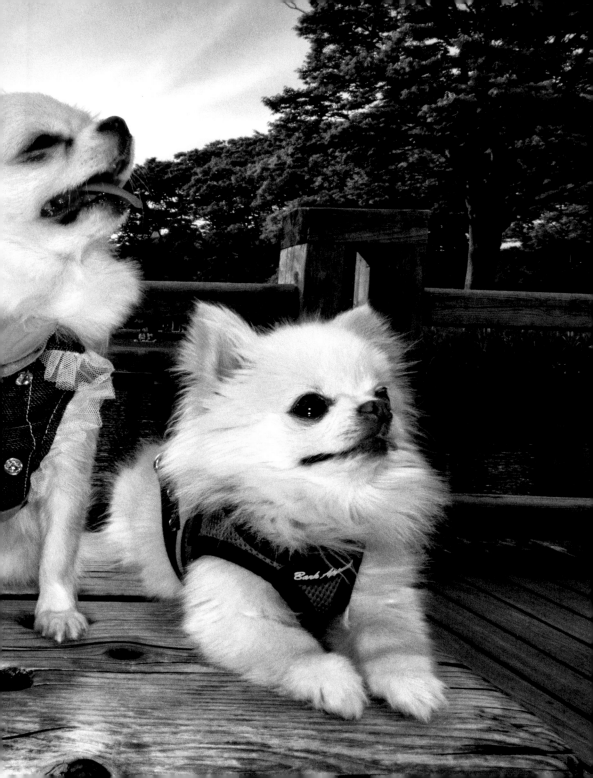

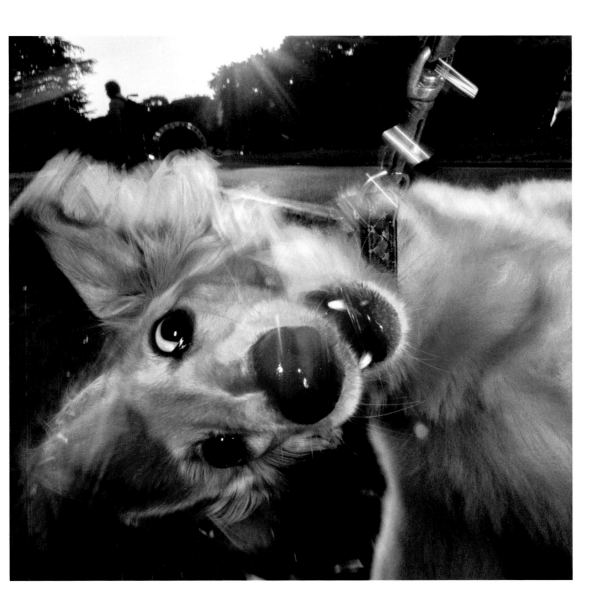

Thanks to Rosie and Poppy; Mum and Dad; Linda, David & the boys.

Special thanks to: Gemma Peppe my best pal, inspiration and for her help with the text, Agata Stoinska, Paul Lowe, Charles Walsh, Stuart Waplington, Leo, Dave Lucken, Nick, The Printspace, Jack Cocker, Andy Laing, Berny McGurk, Richard Bright, BBC Scotland 'What do artists do all day', Martin Parr, Julia Spitta, Maximilian Jacobs, Peter York, Neville and Winnie the Dog, Mark Thackara, Olympus UK.

And to Gary Fairfull, Chris Mc Muck, Pablo Discobar, Ted and Oliver Grebelius, Sean Pollock, Iain McKell, Matt Stuart, Robin Maddock, Veronica Gabbuti, Jocelyn Bain Hogg, David Thomson, David Hoffman, Neil Burgess, David Kilpatrick, Giles Price, Carolina Bohorquez, Des Byrne, Matt Finn, Graeme Oxby, James Stacey, Dan Szpara, Luca Locatelli, Pandora Beresford, Grete, Camper John, Agonda Beach dogs, Johanna Neurath, Maciej Dakowicz, Paul Bennett-Toad, Shannon Ghannam, Laura Noble, Brian Griffin, Louise Clements, Phil Toledano, James Stacey and Dan Szpara, Tom Seymour, Kevin Martin, Kathleen Morgan, Barry Cawston, Eleanor Macnair, Jacko, Jasper White, Clara Borel, Brian Mc Carthy, Homer Sykes, Stu Friedman and Sarah newly weds.

Frank Evers, Matt Shonfeld, INSTITUTE Artist Management; Russ O'Connell, Emma Broomfield, Sunday Times Magazine; Pax Zoega, Simon Bainbridge, Marc Hartog, Diane Smyth, BJP; Martin Usborne & Ann Waldvogel, Hoxton Mini Press; the team at Fotofestiwal Lodz; Nuno Ricou Salgado, Maria Salgado, Flâneur - New Urban Narrative; Maggie and Amy, Eastend Photomonth; David Rojkoshvili, LFI - Leica Fotografie International; Malcolm Dickson, Donna Kelly, Street Level Photoworks; Robin Sinha, Leica Mayfair; Manfred Zollner, Fotomagazin; Dagmar Seeland, Stern Magazine; Dave and Owen, Four Corners New Creative Markets; Lars Lindemann, Geo Germany; Yuichi, Vice Japan; Thea Traff, Max Campbell, The New Yorker; Alan Raw, Hull International Photography Festival; Arianna Rinaldo, Antonio Carloni and the team at Cortona on the Move; Tina, Wolfgang, Beso at Kolga Tbilisi Photo Festival; Sabine Schnakenburg, Krzysztof Candrowicz, Triennial of Photography, Hamburg; Jim And Alex at Lens Culture; Sarah Tagholm at ShelterBox; James Estrin, Stacey Baker, Lens, The New York Times; Stacey, Monica at D-Light Studios; Kettle bells class and the gym staff at Shoreditch House.

And finally Dewi Lewis and Caroline Warhurst for their considerable support and for the effort they have put in to the design, edit and ultimate publication of this book.

First published in the United Kingdom in 2017 by
Dewi Lewis Publishing, 8 Broomfield Road, Heaton Moor, Stockport SK4 4ND, England
www.dewilewis.com

ISBN: 978-1-911306-18-4